creative camera international year book 1975

Published by
Coo Press Ltd.
19 Doughty Street
London WC1N 2PT

Distributed by
Gordon Fraser, London
in Great Britain

La Photogalerie, Paris
in France

Light Impressions, Rochester, New York
in the USA and Canada

Photogravure illustrations printed by
D H Greaves Limited, Scarborough

Letterpress printing by
Watmoughs Limited, Idle, Bradford

ISBN 0-85390-020-5

creative camera international year book 1975

Edited by Colin Osman and Peter Turner

Contents

Creative Camera, at the time this is written, has passed 120 issues; that is ten years of existence. Of course the first years do not count as the early issues of *Camera Owner* would not be recognisable as the same magazine. The only connecting links between then and now being the concentration on the visual image itself and the absence of technical jargon. The evolution of the magazine has been a gradual one based on practical experience in what is, after all, still a pioneering venture. In one sense therefore this Year Book is the logical outcome of ten years' publishing and is designed to do those things a Year Book can do better than a monthly magazine. A look at the contents page shows that the major portfolios are of a size impossible to publish in the magazine. It should also be noted these are portfolios which could not be condensed without serious mutilation.

These major portfolios work on two levels; first and foremost they are simply collections of images by great photographers and can be viewed as such. Secondly these same images will also be seen by those who have studied the work of these photographers in the past; who may own books on or by them and who may have followed their careers for some time. They would not welcome so readily photographs which could be seen in other books. Although obviously this duplication would make little difference to the first group, for the second group we have chosen images with a heavy preponderance of the unfamiliar and with Cartier-Bresson, Atget and Frank there are pictures which have never been published before in spite of their importance.

To a certain extent the whole Year Book is intended to work on two levels. The second of these levels is, to retain the order used in the paragraph above, the particular concern of our regular readers who know the magazine and with whom, from time to time, we meet and discuss photography and photographs. What the Year Book offers to the regular *Creative Camera* reader is a permanent work of reference, a milestone in photography or whatever you like to call it.

The first level of our readers have received very careful thought from us in the selection of material for the Year Book because we feel that there is a danger that we may become involved, indeed instrumental, in producing another photographic art establishment which becomes increasingly introspective and in the end finishes up as experts talking to experts. Any art form is only too easily divided into 'them' and 'us' categories. In modern music, in modern sculpture and so on, these divisions are only too apparent. They should not be in photography because photography by the character of the medium should be, if not popular, at least universal and therefore the Year Book is intended to be read and seen by people whose interest is in photography but is not as committed to any certain type of photography as are our regular readers.

For this reason the content of the Year Book differs slightly from the monthly. In the monthly we examine the photography of the past to assess or re-assess it. We look at the major photographers of today and also we try and look into the future by publishing experimental, even incomplete experimental, work reaching out to possible future directions of photography. Since a Year Book must traditionally be a matter of record there has been far less emphasis on experimental work and a greater emphasis on achievement.

It is called an International Year Book and although somewhere we have counted the numbers of photographers and the number of countries they come from to a large extent this is irrelevant because no photographer has been included because of his country of origin. A substantial amount of American work is inevitable because of the enormous amount of photography that is being produced in America, and their keenness. Eventually any Year Book depends on the material that is to hand and there are many good photographers who would have been included if we had had the pictures.

Although not identical, so closely is the Year Book integrated with the monthly that certain pictures could be almost interchangeable and some of those included in these pages were considered for the monthly primarilarly as is almost inevitable with the younger photographer's work.

Throughout this introduction the recurring words have been 'the photographer' and 'the image' and by now it should be clear that these are our primary concern right down to comparatively minor details. Other Year Books for example will use one photograph from a photographer and may arbitrarily place another picture opposite it which may or may not enhance its meaning. Usually it is detrimental. Such contrasting techniques were used far more humorously and far more effectively years ago in the well

remembered magazine *Lilliput* but such techniques have no place in a photographic Year Book, so each photographer receives from us two pages as a minimum. Of course this is still not enough but it is a very considerable advance on present alternatives.

Not mentioned up to now are the text sections. Although faced with the problem of one or two last minute substitutions in order to meet a rather tight time schedule, the text still represents authoritative statements on different aspects of photography. They will each in their different ways we hope, make progress towards more meaningful photographic criticism.

There is even a technical section but this has been made for a special purpose and is the beginning of a series of articles of particular interest to photographic collectors, whether private or institutional, and those who hope to sell their prints to collectors. This first one is on archival processing and is not intended to be a work of original research but an examination of published techniques and a convenient summary to which and from which people may go for further information. Our experience has shown us that these summaries are badly needed and for many purposes provide a practical amount of information. The series begins in this volume and we will consider in subsequent years a number of other topics, prominent among which will, of course, be the restoration of old photographs.

This then is what the first issue of the Year Book is about. It represents many hours of thought but, because it is like the monthly and constantly evolving, we make no predictions about the future except that we know that next year we shall have to try even harder. Because *Creative Camera* monthly and the Year Book are constantly evolving we welcome not just submissions but discussion and criticism. There is an open invitation for people to write to us about the magazine, the Year Book or just about photography in general.

Colin Osman

ROBERT FRANK

photographs from London and Wales, 1951

Robert Frank is one of the great enigmas of modern art. Now widely acclaimed, his work went unremarked for long enough to give him that sort of rare reputation based on the secret knowledge of the few. Somehow that reputation has endured; it claims for him an admiring mention in virtually every piece of contemporary photographic criticism, and his work is constantly imitated and acknowledged by the *avant-garde* of contemporary reportage. Yet he has practically ceased to work as a photographer, and his name is almost entirely associated with work done over a few years in the early 1950s, particularly that which appeared in his great photo-essay of 1958, *The Americans.*

His role can be compared with that once occupied by Marcel Duchamp, the artist whose very withdrawal from the practice of art claimed attention and give rise to puzzlement. Where Duchamp was an urbane practitioner of art as a game, a sophisticated modernist who made and re-made the rules, Frank appears as a deeply serious fundamentalist, a man subject only to the rules of his own conscience.

He figures very prominently in the conventional account of modern photography. He is invariably listed with Diane Arbus and Lee Friedlaender as one of those photographers who exemplifies the new uncompromising modernism. It was principally his sombre vision of the world which disturbed and then ousted the humane and optimistic picture making of the immediate post war years. This mood reached its fullest, even encyclopaedic, expression in Steichen's great Family of Man exhibition in 1955. In the light of this vision humanity was one, despite race and religion; man was on the whole industrious and genial, sharing the same splendours and the same miseries. Both Robert Frank and Diane Arbus were represented in this exhibition, but by 1958 *The Americans* had been published and the mood had changed.

By the late 1960s the world had been made anew by photographers: the old homogeneity may have been retained, but its humanitarian bias had vanished and increasingly man appeared as the victim of his own follies, dead, mad or deformed. The photographers in the public eye during the early 1970s are such specialists in the alienated as Diane Arbus, Les Krims, Charles Gatewood and Bill Owens. American photographers in particular during the 1960s turned from the portrayal of a benign humanity to an insistence on the corrupted face of man which recalls the European art of Grosz and Dix at another time of crisis in the early '20s. The Vietnam war may have directed attention away from the optimistic world picture of the early '50s but if the figures in the new landscape were dominated by anyone it was by Robert Frank with his pictures of a sombre and often degraded life lived out precariously on the road's edge.

This is a simplified account of the history of modern photography, but it is true that this evolution is most usually seen with Frank's collection of 1958, *The Americans*, as the point of transition. Its influence was gradual rather than immediate, as though Americans themselves only slowly came to recognise this as the picture of the flawed actuality of the American Dream. In the middle '50s it is still a foreigner's view of the country; this is the period of Nabokov's satiric topography in *Lolita*, written during the early part of the decade at a time when Frank was also journeying through the United States.

The only exceptional thing about Robert Frank's approach to America was his cultivation of the mundane. Like so many other photographers before him he was a tourist and unavoidably he came to the famous places, to the places of curiosity and notoriety which are the focal points of tourism. He looked at the great cities, at characteristic types and occupations, and in Britain some years before he had followed just this sort of photographer's progress from the grimed miners of Wales to the bowler hatted City men of London. In America he followed the roads to see famous names and the ethnic minorities of folklore; he saw Blacks in the South, Jews in the big cities, Stars in Hollywood and Westerners at the rodeo. His picture titles are a guidebook tabulation of the places great and small of the United States: underlying the collection is the tourist brochure with its technicolour glimpses of the curving motor road, the Statue of Liberty and Las Vegas by night. To Frank these are some of the co-ordinates against which he works his parodies. In the fictive America the Westerner is a stalwart hero; in Frank's version he is a street idler in cowboy dress, an anonymous pastiche in a neon-lit bar.

Just as Cartier-Bresson had given us *The People of Moscow* in 1955, the classic photo-journalist's view of a community on parade, in leisure and at work, so Frank's people form a complete world in social and private life. Where the rule and the intention

had always been to make a picture which summed up a place or a type or an event in its recognisable completeness these pictures do little more than to refer to this aspiration. Frank keeps only the name; it is Detroit or Chicago, but it could be anywhere with apartment blocks and jaded people. It is as though his experience bore no relation to the conventions and fictions proposed as the idea of America. The names may be redolent of glamour, of a heroic past and an optimistic tradition, Santa Fe, Chattanooga, Belle Isle and Butte; he acknowledges this in the roll call of his titles and in his constant allusion to political and religious ideals, to images of leadership and reverence, St. Francis, Washington, Lincoln and the flag itself, but the inescapable actuality is of desolate roadsides, impoverished hotels and the tedium of travel. The ironic interaction of title and mundane image mocks the whole tradition of the significant conclusive picture, and it seems to be from this that the whole snapshot aesthetic of recent photography evolves.

In London Frank had toyed with this play on the fictive image of the country and he looks for City men and the town clothed in Dickensian fogs, but in America the very idea of the country projected by its social symbols seems to have been more transparent and more at odds with the things which he saw on every side and, thus, a far richer hunting ground.

In his work he presents a whole new iconography of the alienated landscape; his is the sensibility, in part, of the Pop artists of the succeeding years. He anticipates the unadorned presentation of the mundane which is a feature of Rauschenberg and Warhol but working as a tourist photo-reporter he is acting in an area of well-defined conventions and within these his pictures can only function as satires and parodies. To have done only this would have secured a reputation but in truth he far transcends the role of critical observer. Like other photographers he sets the real and the ideal in sharp contrast but no matter what the ostensible subject it is caught up and thoroughly shaped by his own fundamental vision of good and evil.

His pictures have a melancholic air remote from the 'good-time' photographic reporting of the era. His subjects are acquainted with grief and near neighbours to death. From the beginning he seems to have been drawn to the skull beneath the flesh, and his early photographs in his anthology *Lines of My Hand* (1972) demonstrate this preoccupation with death and isolation. In London he photographed a hearse in a desolate fog-shrouded street and contrived to place a refuse cart seen through the frame of the open rear window. In America, he returned again and again to funerals and memorials. On "U.S. 91, Idaho", he shows three crosses on the scene of a highway accident with the light flooding in through the dark clouds; it is a picture with no effective precedent outside the work of Rembrandt.

Before his American work there is a macabre element in his pictures; gradually this is assimilated during the early fifties and it survives as a natural part of the sobriety of the images, integral with his insistence on the pervasive opposition of black and white, the lightness and the dark. It may look at times as though he has a moral purpose when he shows, for instance, a black nurse and a gleaming white baby but this polarity in his work passes far beyond matters of justice and equity. He seems to be pointing to the inseparability of blinding light and the most impenetrable shadow. They are constantly in dramatic interplay in his pictures acting out some remote and elemental drama in which men are passive and uncomprehending witnesses.

Of course, the structures of his pictures can be imitated and they have been; in working through systems of contrasts he is following a conventional practice widely developed through the 1930s. The cultivated informality of his picture making has also been suggestive, but without his sombre informing vision these can be mere devices without meaning. His uniqueness is to have made a wholly new elision of the topical and mundane with a personal and awesome metaphysic of darkness and light.

Ian Jeffrey

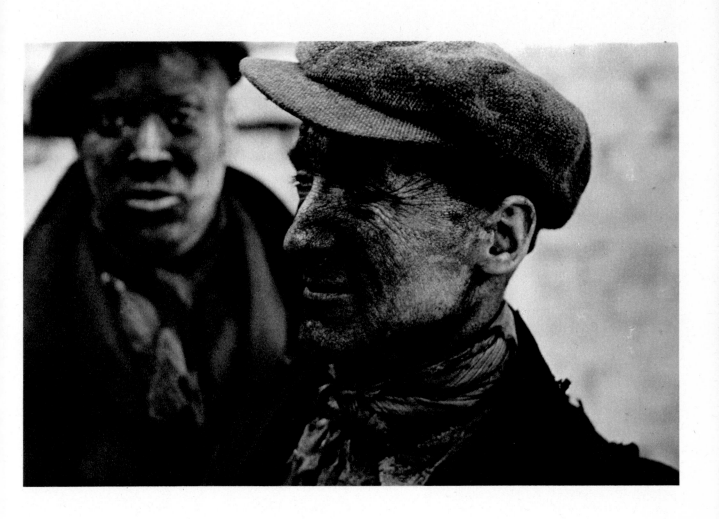

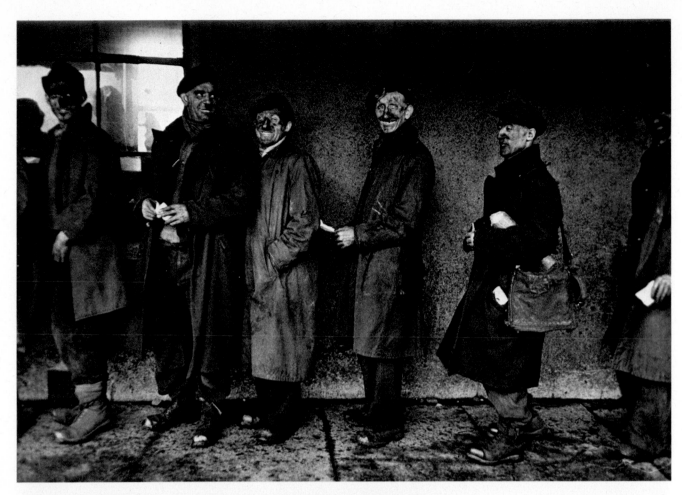

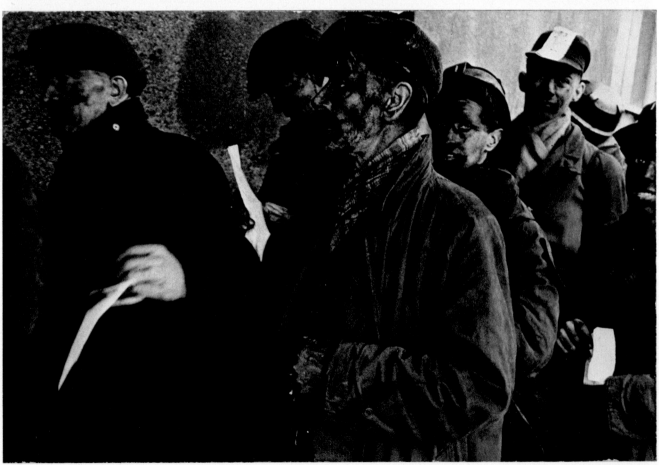

14

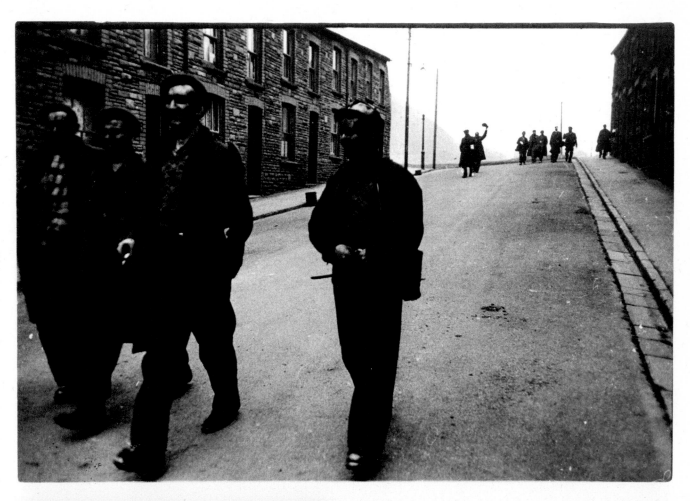

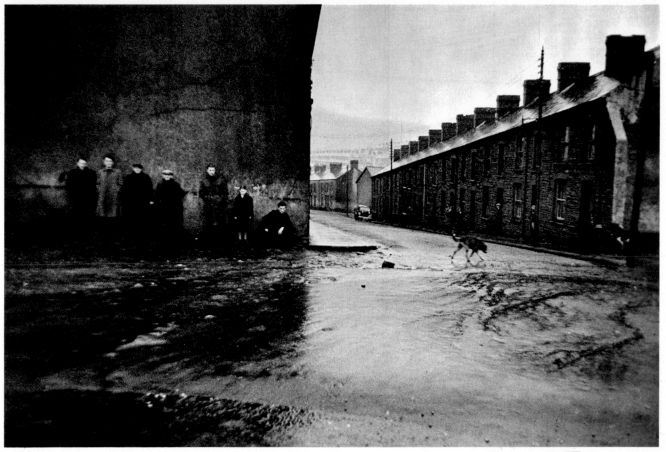

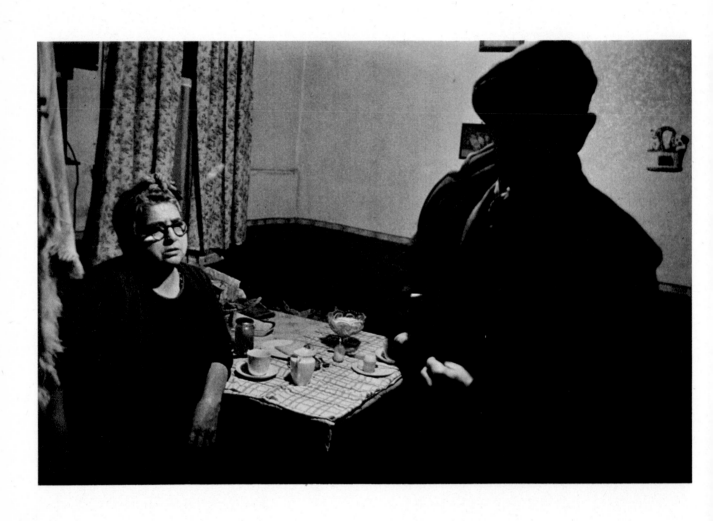

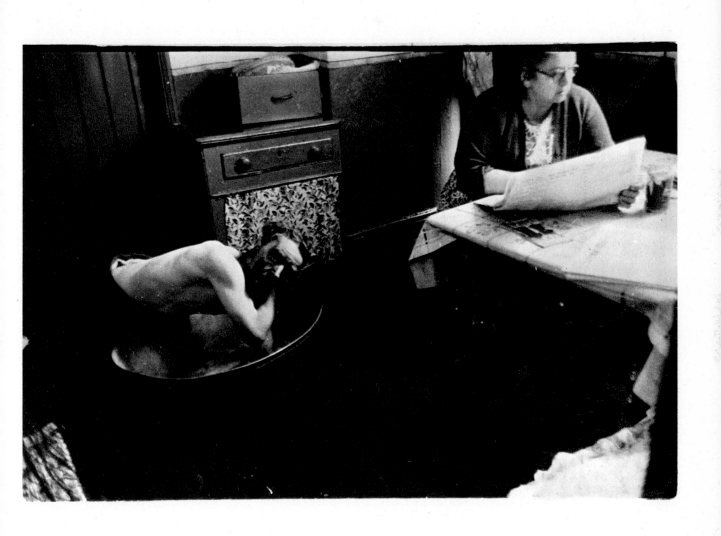

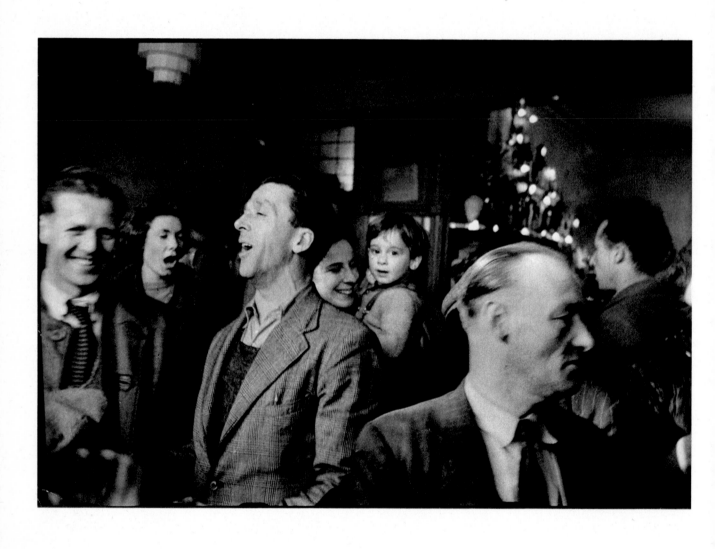

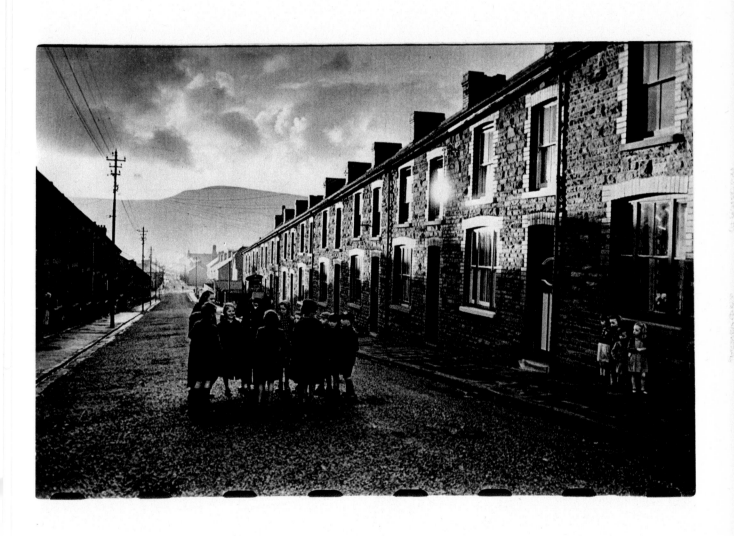

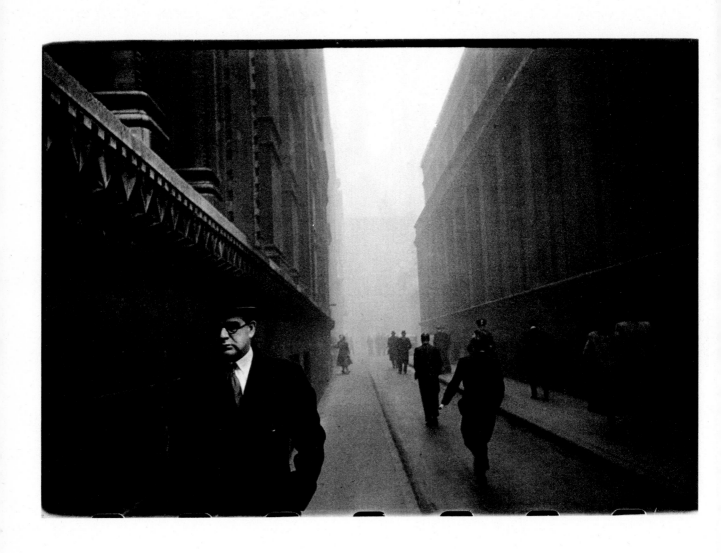

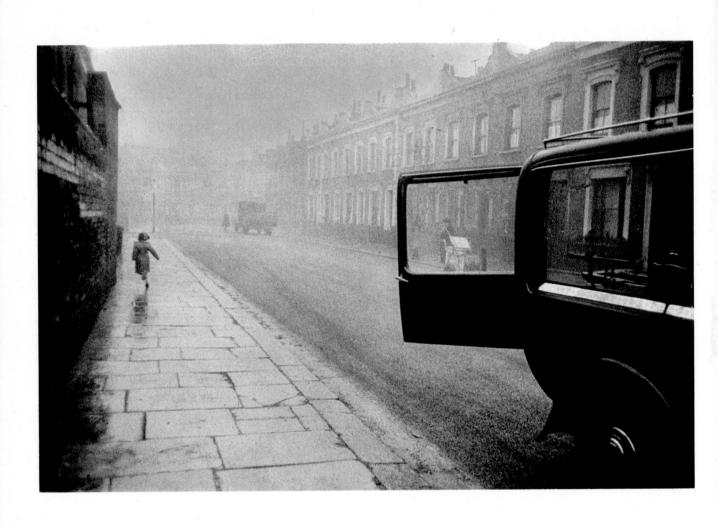

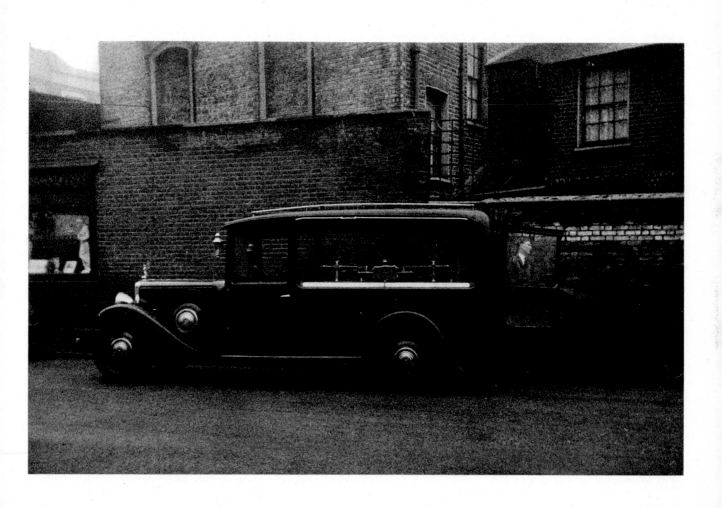

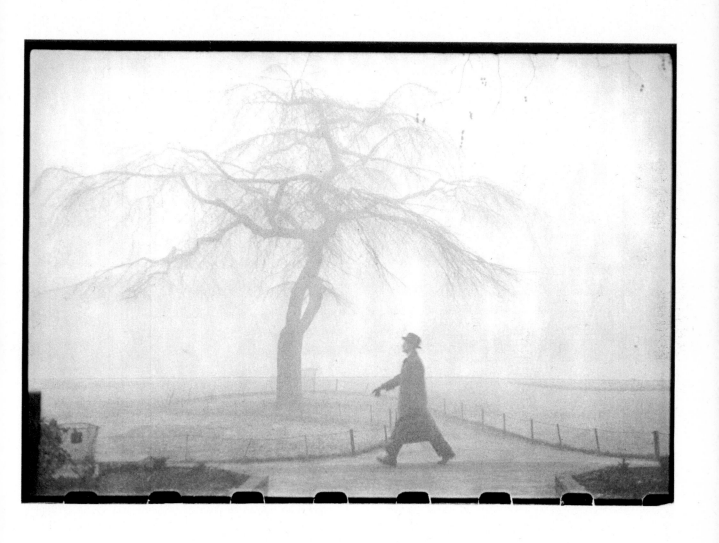

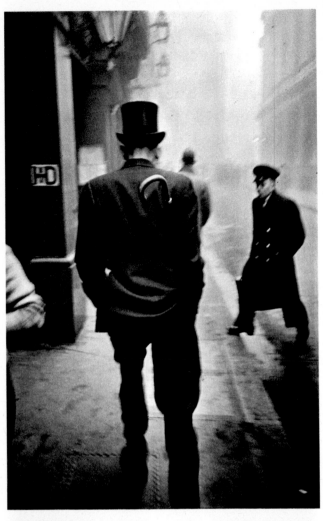
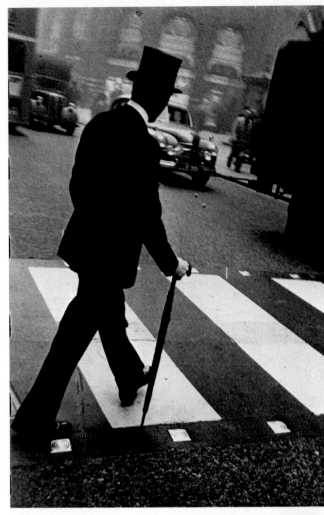
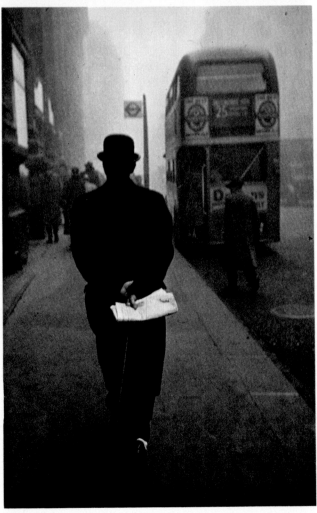
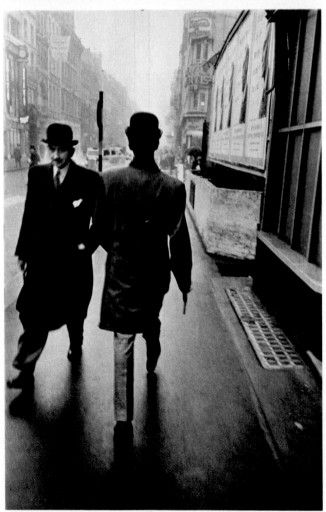

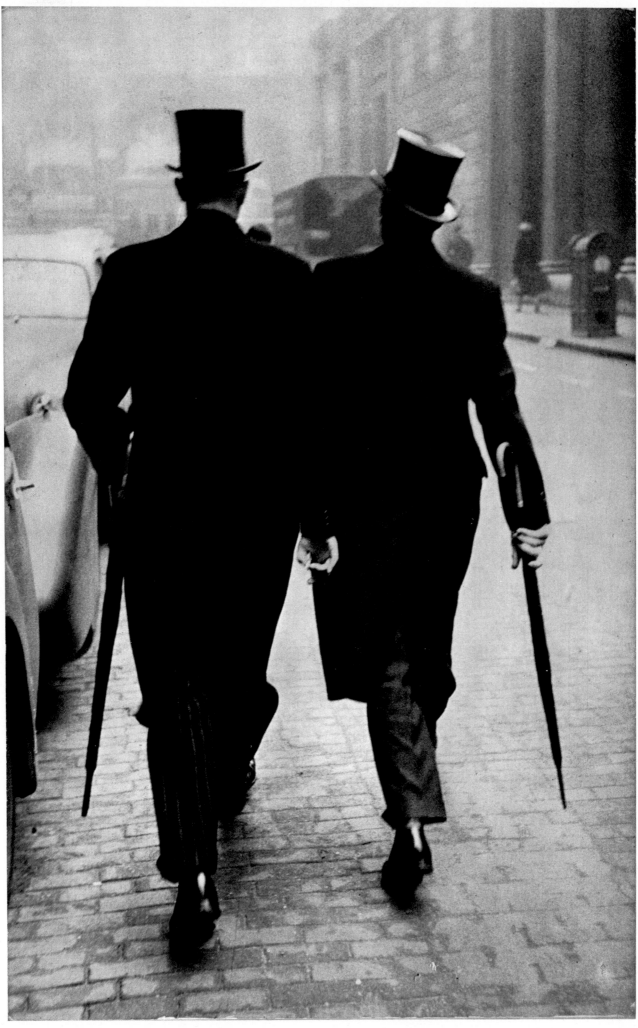

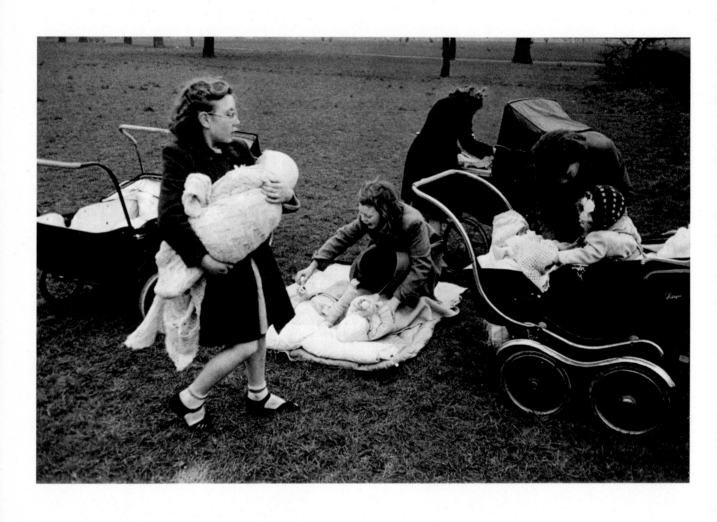

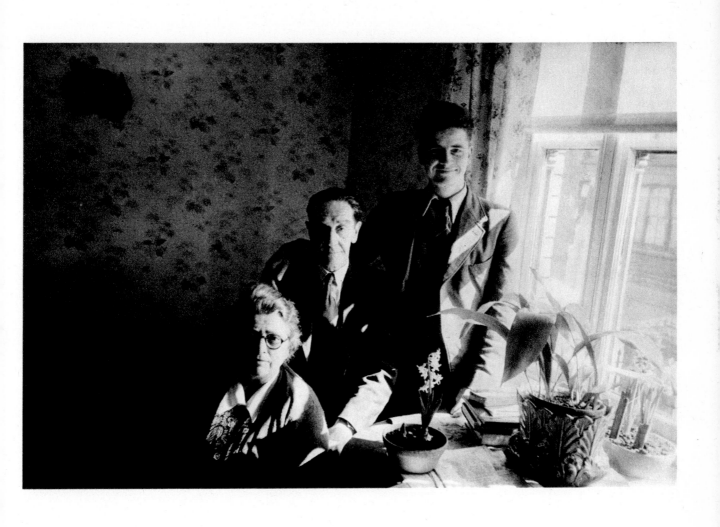

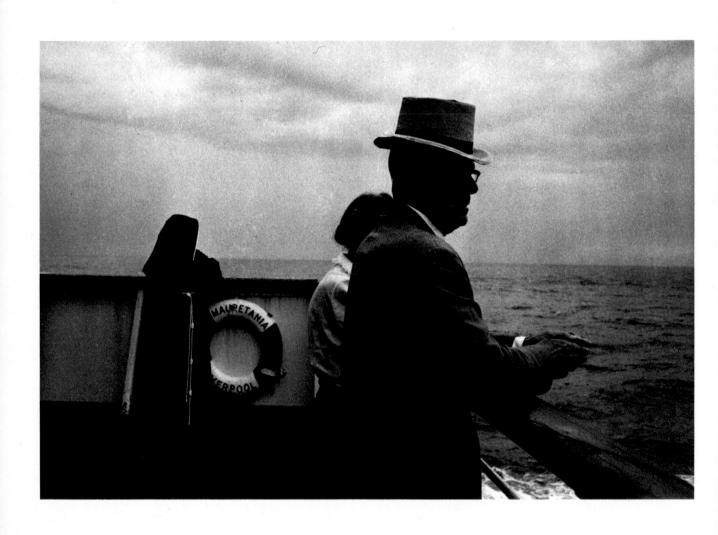

Young Contemporaries

Young photographers and the language of photography

Recently, whilst reading an American Magazine I came across the phrase 'Everybody is looking for a way to express themselves'. I pondered the meaning for a few minutes in terms of photography and concluded that this was by no means an overstatement when one considers the enormous increase in interest in the medium over the last year or two. Unfortunately not all photography is worthy of being classified as expression, and it would appear that there is an urgent need to re-appraise the whole meaning of the art—if it is an art?

When one considers that photography is now being taught in primary and secondary schools as well as post school level, and in the near future may well feature in university studies, it is time to begin to analyse and identify the fundamental concepts which appear so attractive to so many people. It is true that photography is the number two National hobby (after gardening!); it is probably also true that it is the least understood in other than technical terms.

One recent argument for the growth of photography is that children are now growing up with an unnerving acceptance of television in the home and the school. They are bombarded with moving and still images from all sources, at a rate which begins to unsettle the adult. Unfortunately, the child is often unable to 'talk back' and also unable to bridge the transition between visual and verbal language thus creating a tremendous self motivating potential for increased visual understanding. It is inevitable that we are about to enter an age when the human race has never before been so visually sophisticated and aware. If this new generation of visually fluent people are to be understood, then there is now a need for everyone to begin to learn the language of communication and understand the motivations underlying the 'I want to express' image makers. Photography is a means whereby one can become 'literate' without the time problems underlying the traditional artist. Visual literacy cannot be achieved however without considering the traditions and contemporary social influences which have driven or now compel people to want to express and communicate. Photography was invented through a desire, on the part of artists, to communicate the delicate images found in the camera obscura to their friends and colleagues. Perhaps we have turned a full circle since 1839, a circle of investigation, technological development and sophisticated hardware. Yet we are still not fully understanding *why* we feel compelled to communicate our image-feelings. To the average man in the street, photography is one of two things. Either a way of recording his holiday as snapshots—which can be seen in itself as a valid form of folk art, or he sees photography as a way of making a fast buck. Often he will expound visions of 'Blow Up' fantasies of knicker clicking pseudos chasing dishy flatchested birds through the surf of some desert island. All in all a rather sad impression of the most powerful form of communication and expression ever devised.

The most encouraging aspect of photography at the moment appears to be inextricably tied up with the new emerging generation of young photographers who are, comparatively speaking, more visually literate than ever before. Not only have they chosen photography as a way of communicating what they see, but perhaps, more important, they have *identified* with the medium as an instant, expressive art form. They demand to know more and more about the potential of the medium, the traditions in terms of the great workers of the past, and what the future holds.

Considerable thought and discussion is given to the need for understanding visual language and to the need for criticism and literature in photography.

It appears to me that the key to the whole question of photography lies in a duality of philosophy. The new generation of photographers will build their own language; they will self educate until they are visually literate; they will endow photography with a new stature within the fine arts. On the other hand we can learn from the efforts of the old masters of photography, for, though the technology has changed, the one thing that has not, and probably will not change is that of the question of what we are trying to do when we feel the desire to make a photograph. It is certain that the invisible forces which gave creative power and drive to Stieglitz, Steichen, Lange, Weston and others will equally be driving forward our, as yet, un-emerged television children of today. I personally look forward with considerable excitement to next year's young photographers, though I am quite certain that they will once again be asking the same old questions.

Bill Gaskins
Head of Visual Communications
Sheffield Polytechnic

Antonio Leale

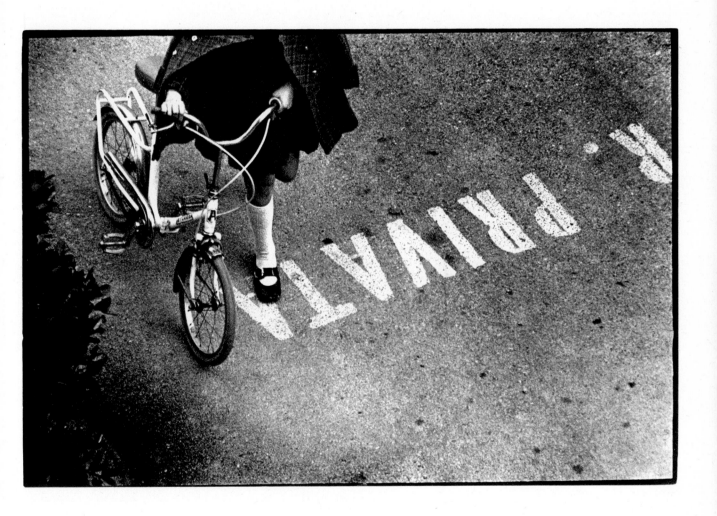

Antonio Leale

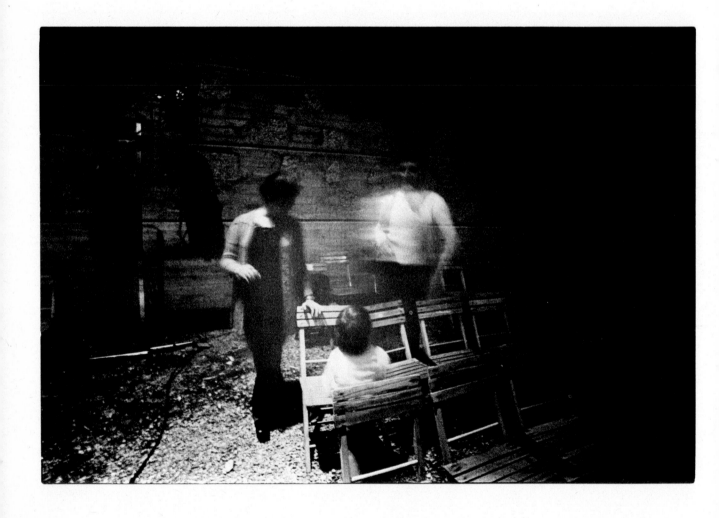

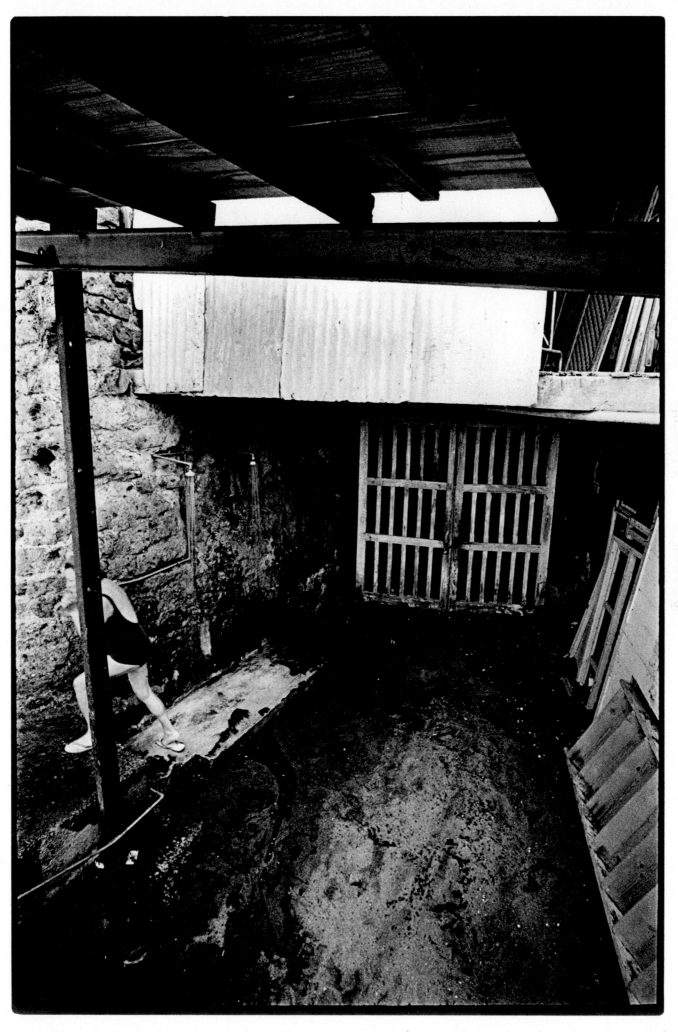

Mark Antman

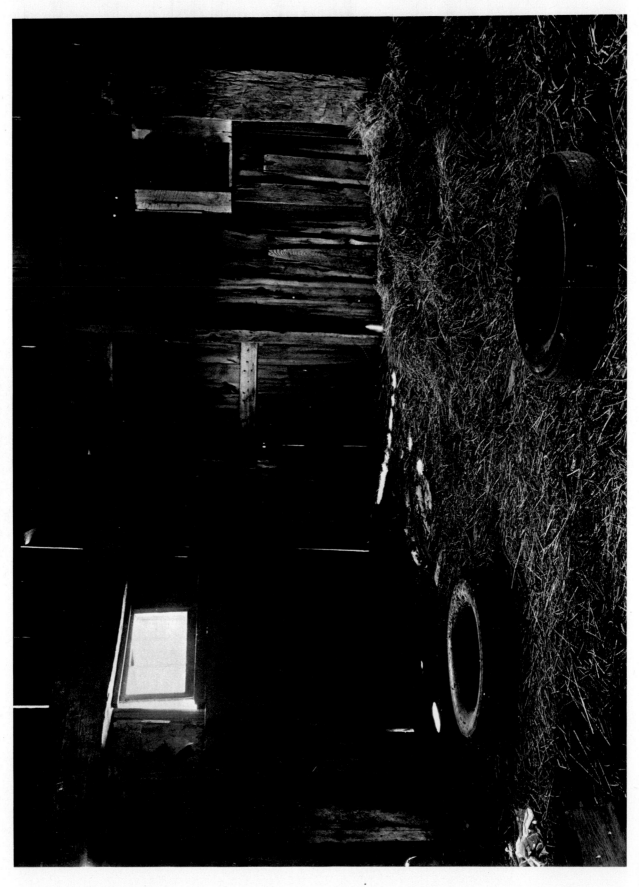

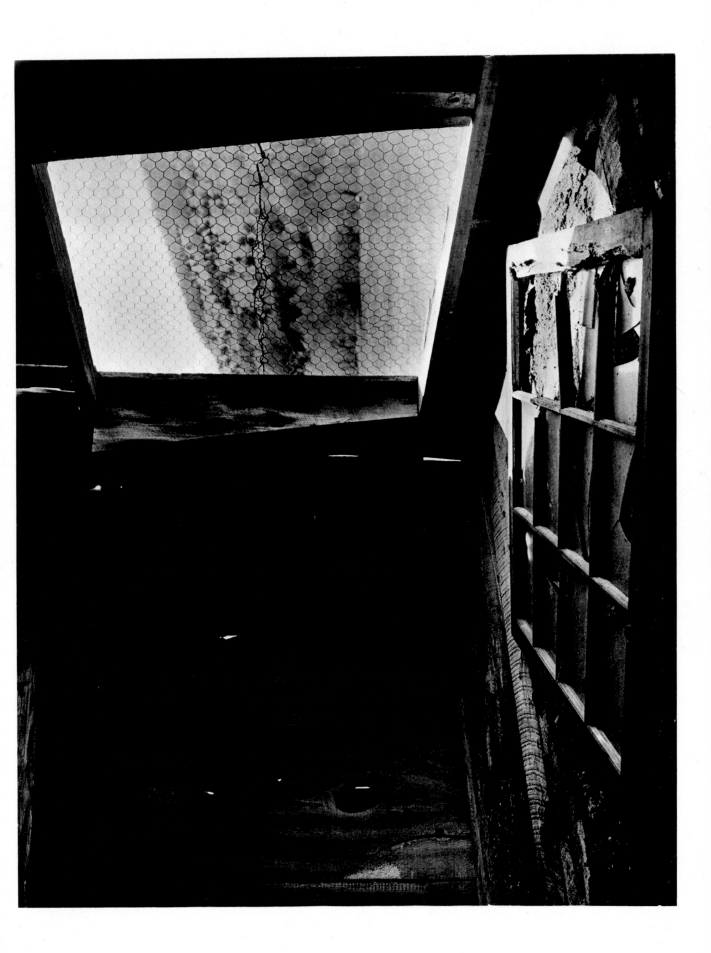

Ron Leighton

Erica Lennard

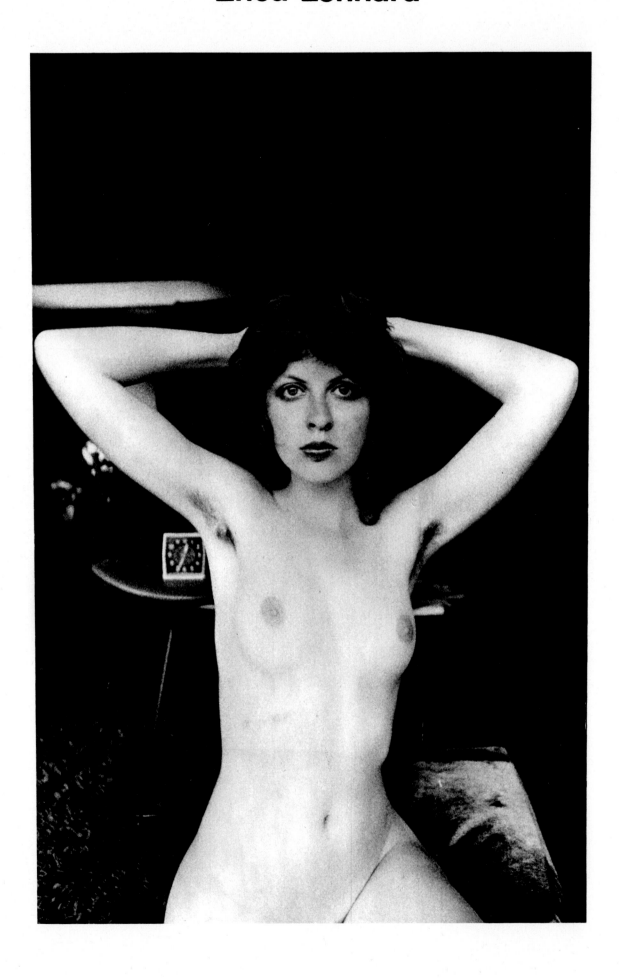

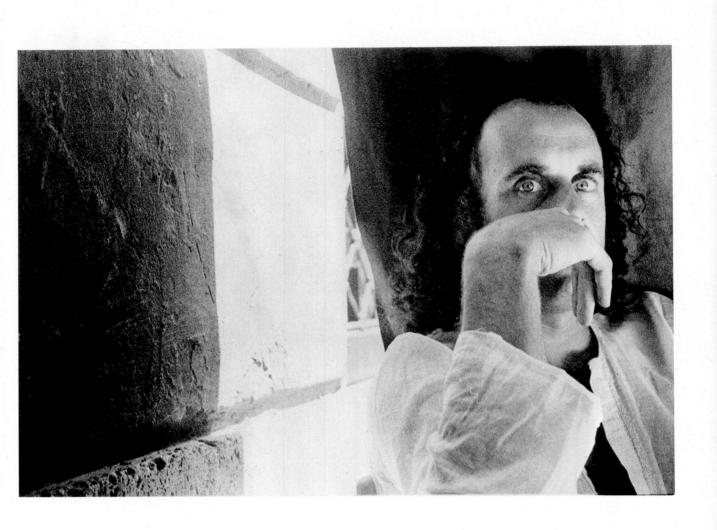

Erica Lennard

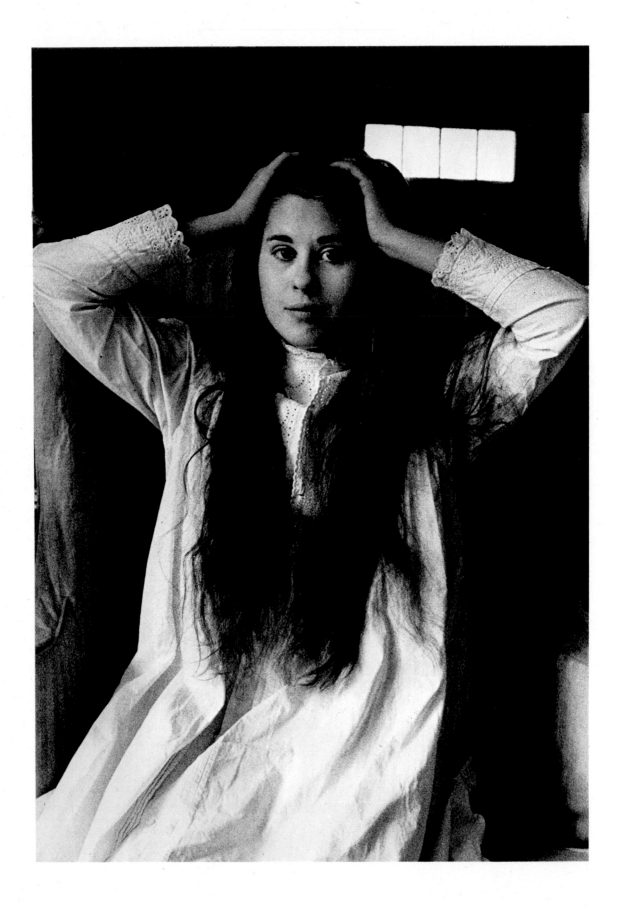

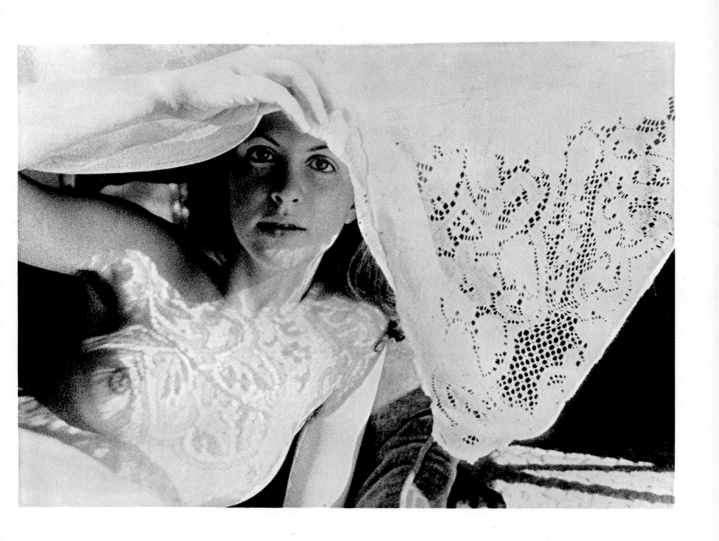

John Webb

Lucia Radoschonska

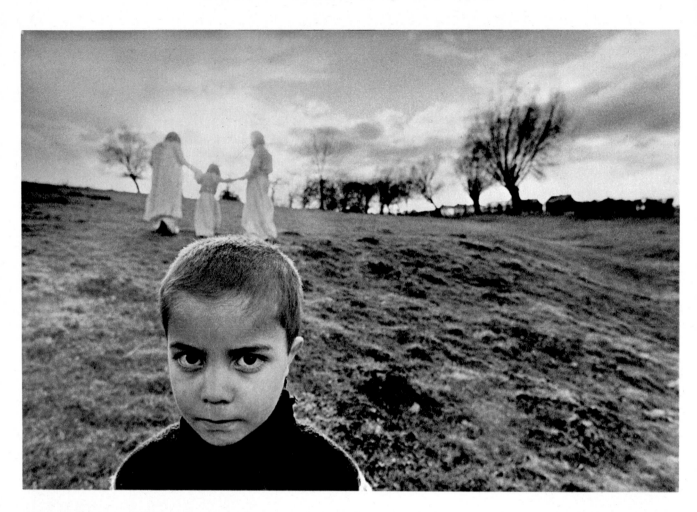

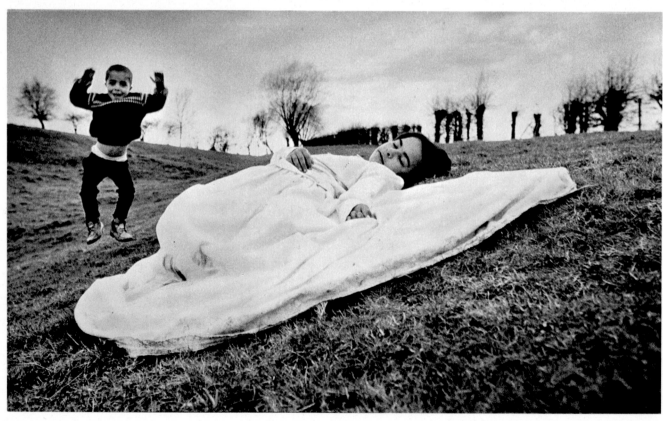

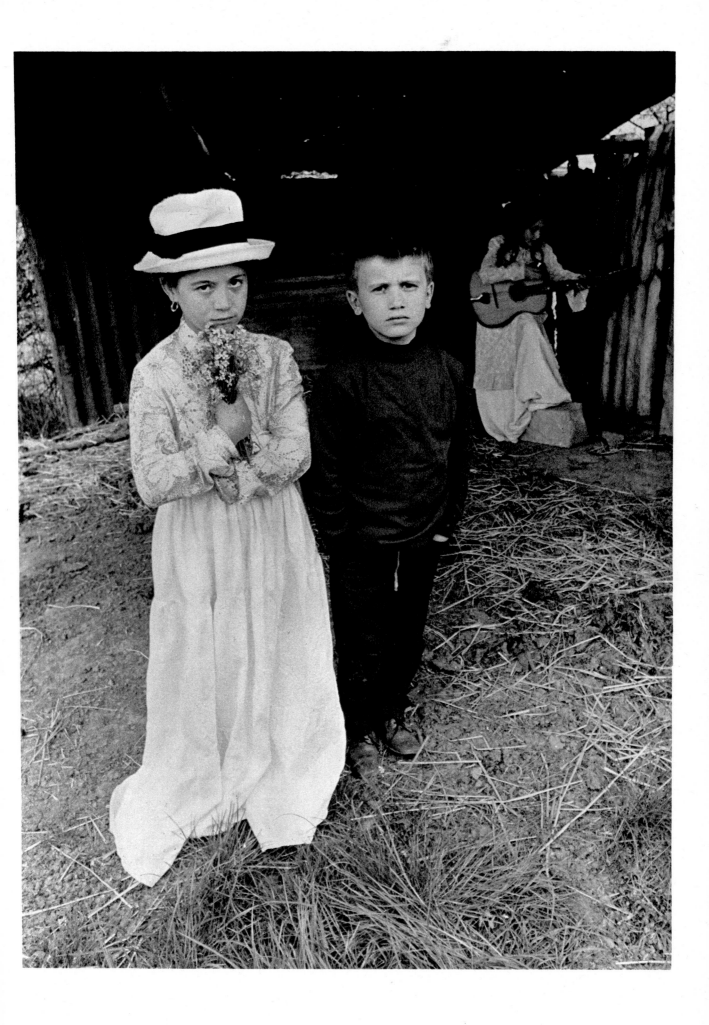

Roger Birn

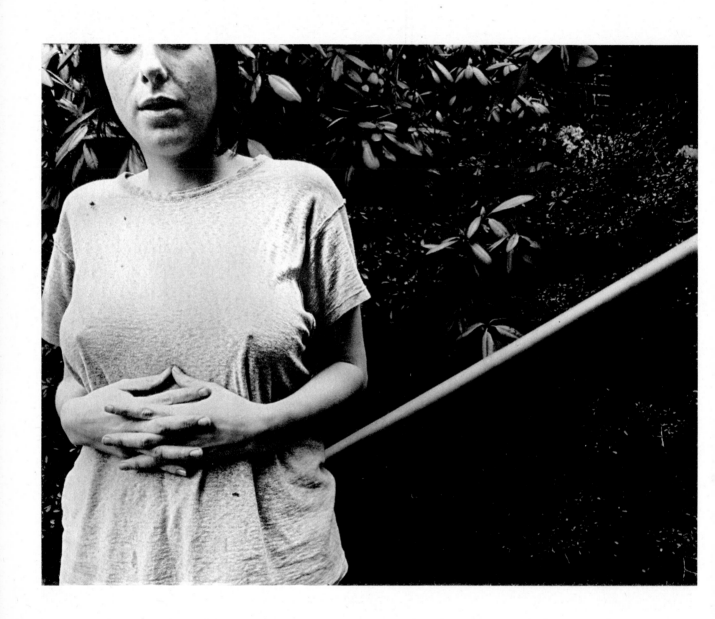

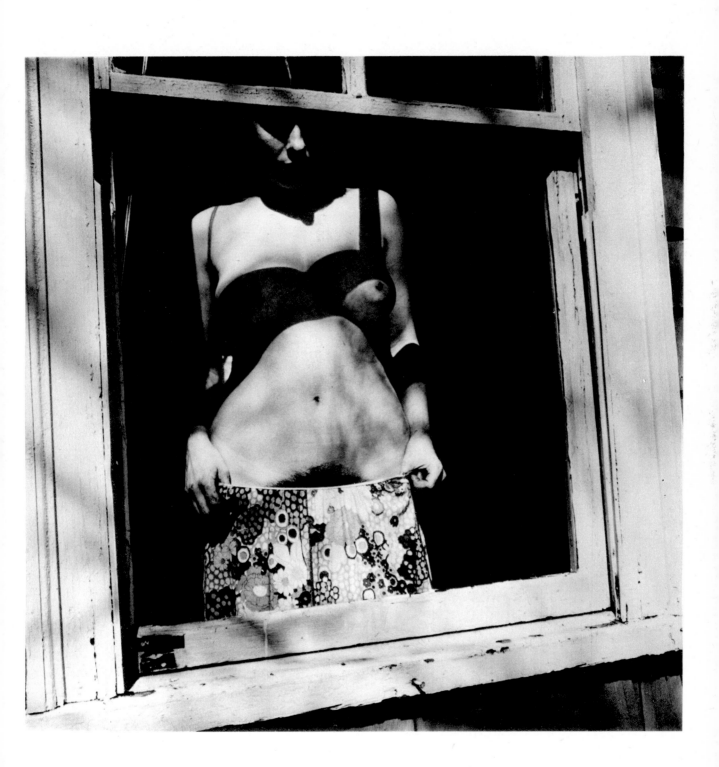

Roger Birn

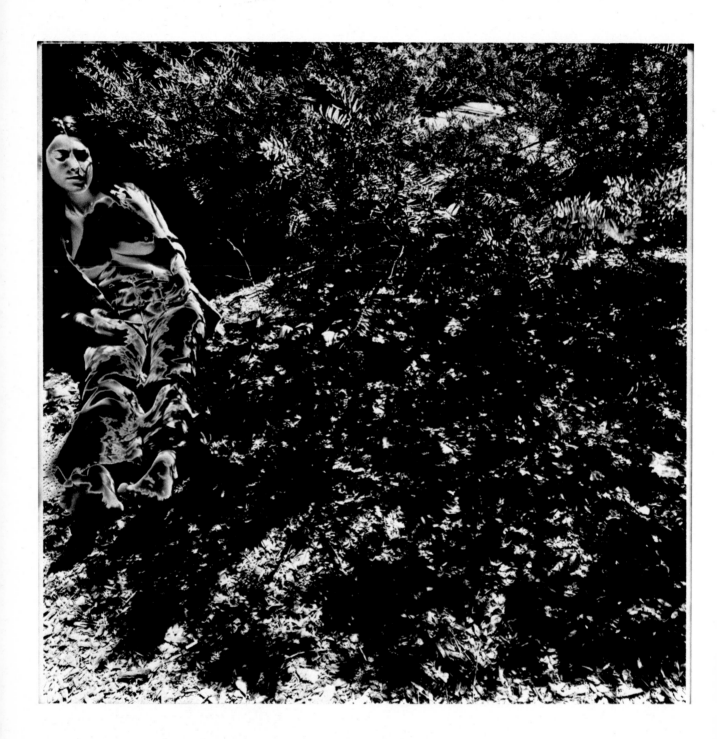

Dennis Finn

Heinz Hebeisen

Paul Rogers

Paul Rogers

David Looms

Ann Christine Eck

Ann Christine Eck

Henri Cartier Bresson

Some months ago, during a misty afternoon in March, we sat in Henri Cartier-Bresson's whitewashed Parisian flat overlooking the Tuileries garden near the Louvre Museum— far away, you could see children playing amidst the statues and the trees and hear from the distance the hubbub of the constant flow of cars. Here we chose the pictures for this portfolio.

This selection, as is any selection, is of course partial, subjective, subject to changes of moods and interests, open to criticism. The fact that it was made from HCB's master file, strong in the 380 pictures Cartier considers his best, is anyway a kind of reassurance.

Cartier's fame is now worldwide. Just as Picasso's name and work stands for painting, being known and praised the world over, even by those who do not know anything about painting, so does Cartier-Bresson's name stand for photography. Everybody has heard of his founding of Magnum Photos with Robert Capa, George Rodger and David Seymour just after the war, of his uncanny ability to be present when and where history hits a certain part of the world, be it India at the time of Gandhi's death, China during the last days of Chiang Kai-shek government, Indonesia when the Dutch left, Moscow just after the cold war or China again at the time of the 'great leap forward'. Everybody has read about his theory of the decisive moment,[1] this miraculous psychological climax when composition, emotion and meaning of a scene come together, giving it life and eternity. Cartier has been for many years a kind of living legend of photography.

But nowadays his standing among fellow photographers is a complex one. If he is still revered for the classic qualities of his work—simplicity, restraint, harmony, proportion, and also for what he represents, the refusal to undertake advertising work, the embodiment of the romantic image of the photo journalist roaming the world with one Leica and two lenses, the freshness of the approach, be it in the subjects photographed or in the way they are photographed; his position as an inspiration to young photographers is growingly challenged.

Two tentative explanations can be given. Firstly the concern for reportage, which contributed most to HCB's fame is slowly fading away. The everyday life scenes of far away places, which were so interesting in the period 1930 to 1960 to a world growing conscious of its diversity and freed at least from the limitations imposed by the war, has become for our spoiled eyes only dull cliches. The constant flow of pictures from TV and from the numerous imitators of HCB (without his genius alas) has saturated our thirst for travel pictures by showing us again and again the same street scenes. And, anyhow, often we have been there ourselves. To be recognized a travel picture must now be spectacular. HCB pictures are not spectacular, they are merely beautiful and true.

Secondly in a time where photography becomes more and more aware of its past and its future as a medium, HCB's concern for life over and above any concern for photography as a self sufficient medium makes him look almost as a wealthy amateur, whose work can be enjoyed, but doesn't deserve to be studied in depth.

The more influential of today's photographers—artists like Lee Friedlander, Diane Arbus, Les Krims, Duane Michals, are all photographers deeply aware of what has been done before them, are all artists whose work is primarily an intense interrogation in what photography is all about. They are in a way 'second generation photographers', whose images can be understood only if related to those of the earlier masters. Cartier's pictures can be enjoyed and understood on a first level by all, as they spring from a lyrical and intense passion for life.

One of the best keys to understanding HCB's work and its greatness is to compare it with that of an honest and sincere amateur. This simile is only apparently paradoxical as Cartier likes to speak of himself as an amateur and his pictures in fact show at the highest level the very basic qualities which give so many snapshots their lasting value.

In his pictures, one can feel the same tender concern for the subject, the same desire one can feel in the pictures of a mother photographing her child, to let it speak for itself without intrusion from the photographer. But what makes him unique is his ability to give to his feelings an aesthetically satisfying form, always in line with the nature of the subject and the emotion it provokes, always fresh and natural.

[1]See the introduction to 'The Decisive Moment' (Simon and Schuster Ed. 1952) reprinted in Nathan Lyons 'Photographers on photography' (Prentice Hall Ed. 1966)

His images, uncluttered and disciplined by a spare economy worthy of Poussin, are full of excitement for the eye, they show grace, balance, surprise, tension and visual wit. They always ask a question and the riddle is part of their strength. They show the real world and yet they verge on the surreal. They rely on basic geometric shapes and interplay of lines, but are no empty abstractions as they spring from an intuitive response to life. They are unmistakably his.

But this passion for life is not that of an undiscriminating visual glutton. He has a novelist-like ability to understand a situation, a country, a person in its truth and as it stands at a certain moment in history. Neglecting the merely picturesque, avoiding the contrived or preconceived ideas, he knows how to probe deeper into a situation till he gets to the drama going on in every life. He is a kind of lyrical sociologist who never hides the harshness of reality, who sees life clearly and knowingly. The more one knows about a country, a person, the more one is able to appreciate fully the subtleties of Cartier's pictures.

His oeuvre is a kind of visual diary, the diary of a well bred liberal individual of the 19th century facing a changing world and trying to understand it, express it and express himself at the same time. Neither a dull documentary of life around him nor an expression of one's feelings as if they were of any importance in themselves, but a personal point of view on the world. And there is no other photographer whose range of interest has been so wide, who has shown with more depth and universality people and their relationships, the diversity of individuals and the uniformity of classes, nations, races, cliques, the turmoils of nations, men versus machines, people and art, nature still untouched and the crowds from the big cities, the faces of the famous and those of common people, upper and lower classes, the States, white and black, Asia and Europe, the charm of childhood, the biblical landscapes and an obsession with death.

Not all HCB's pictures are masterpieces. Some are merely anecdotal, others almost too pretty or leaning towards sentimentalism. But when everything comes together well, personal emotion, insight into the subject, composition, he produces those beautiful and memorable pictures, which can be viewed again and again, whose visual intensity and sharpness of feeling surprise and astonish always, as on the first vision.

D. H. Seylan

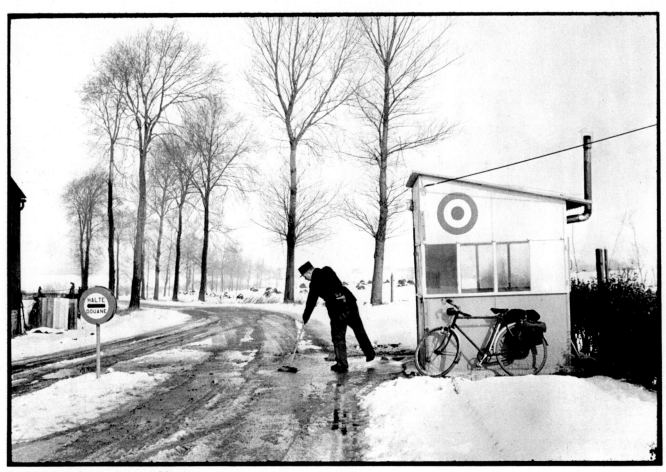

On the French-Belgian border, 1968–69

Near Chambord, France 1970

Deauville, France, 1973

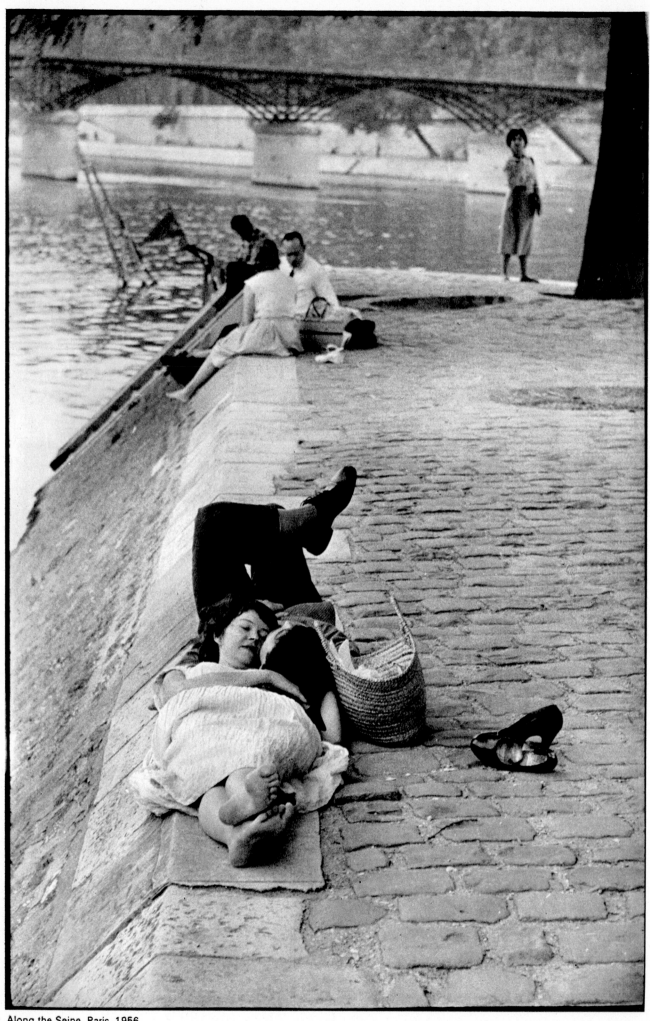

Along the Seine, Paris, 1956

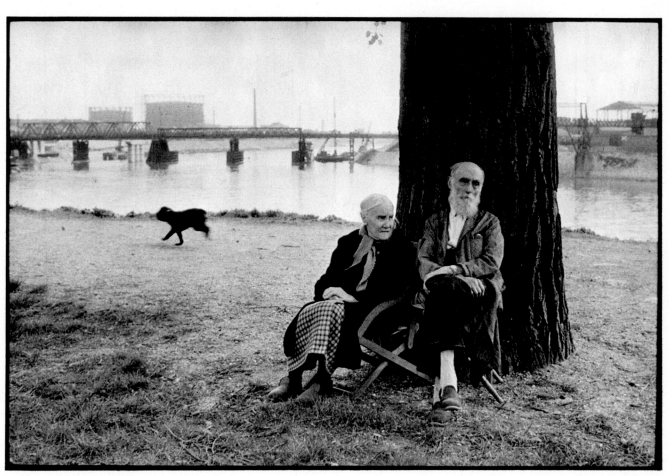

The Seine, near Paris, 1958

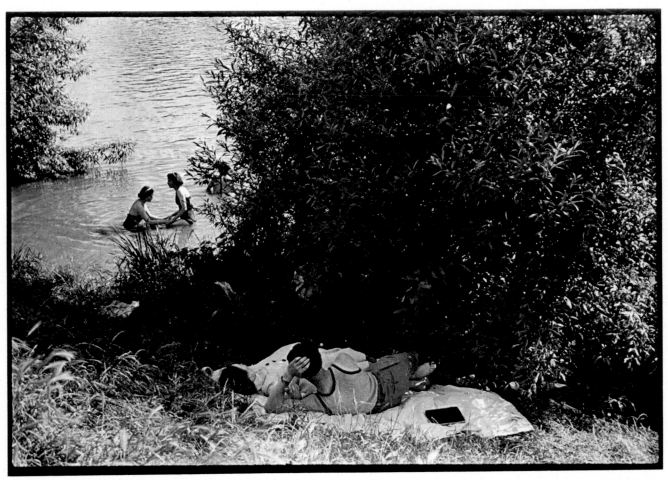

Along the Marne, France, 1936

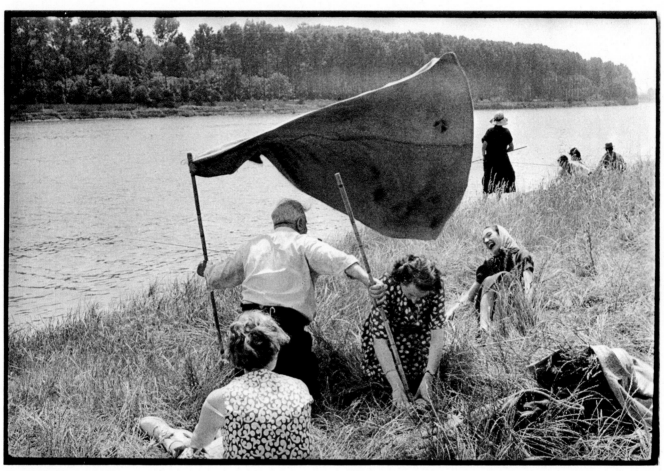

The Seine, France, 1960

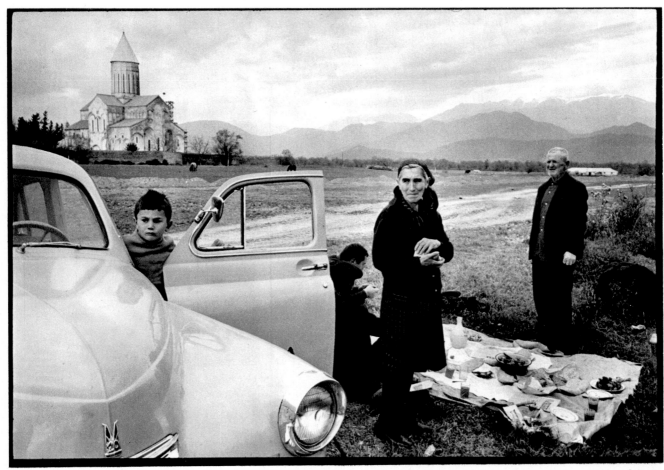

Georgia, USSR, 1973

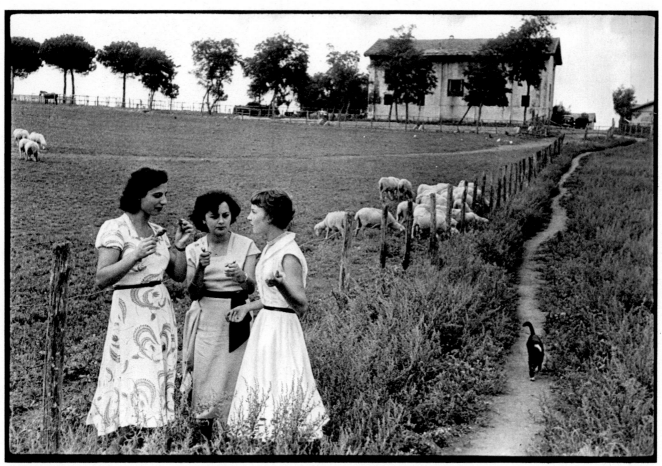

Near Rome, Italy, 1962

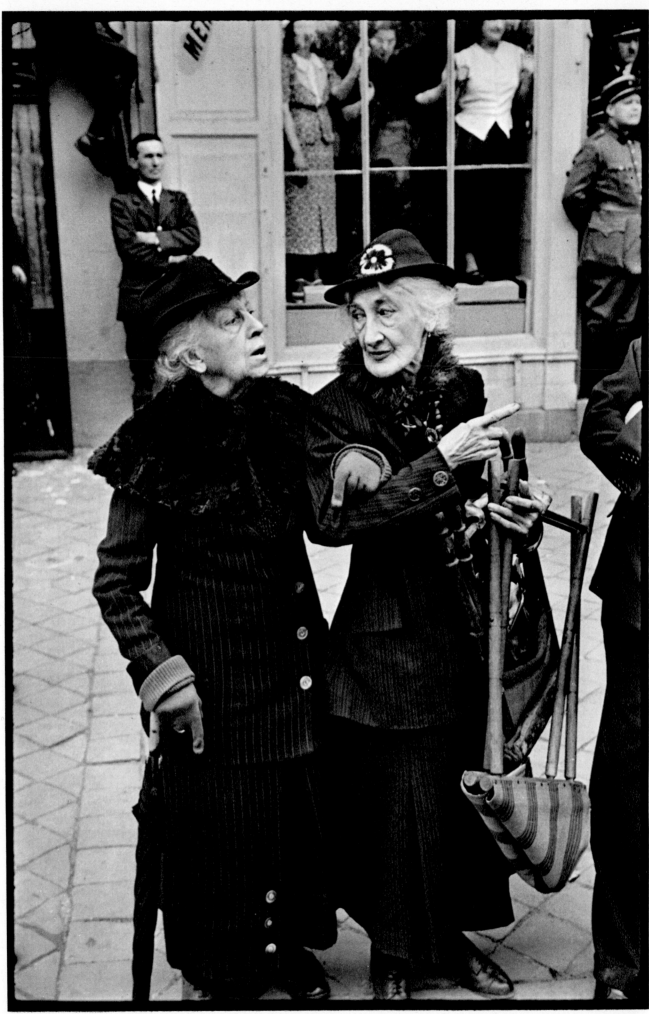

King George VI visits Versailles, 1937

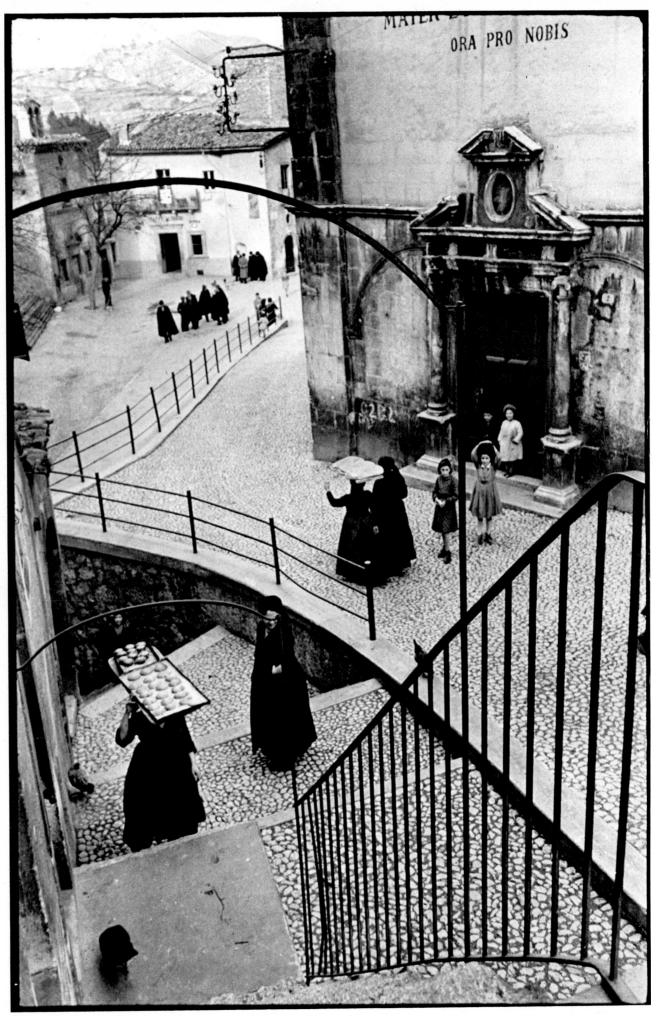

Scanno Abruzzi, Italy, 1953

102

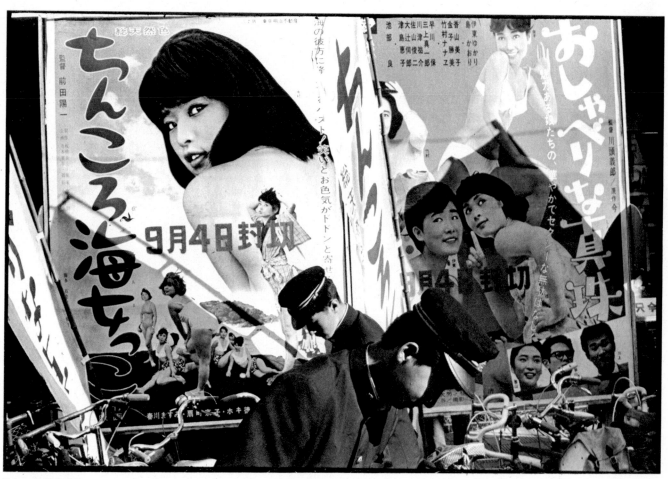

Tokyo, 1965–66

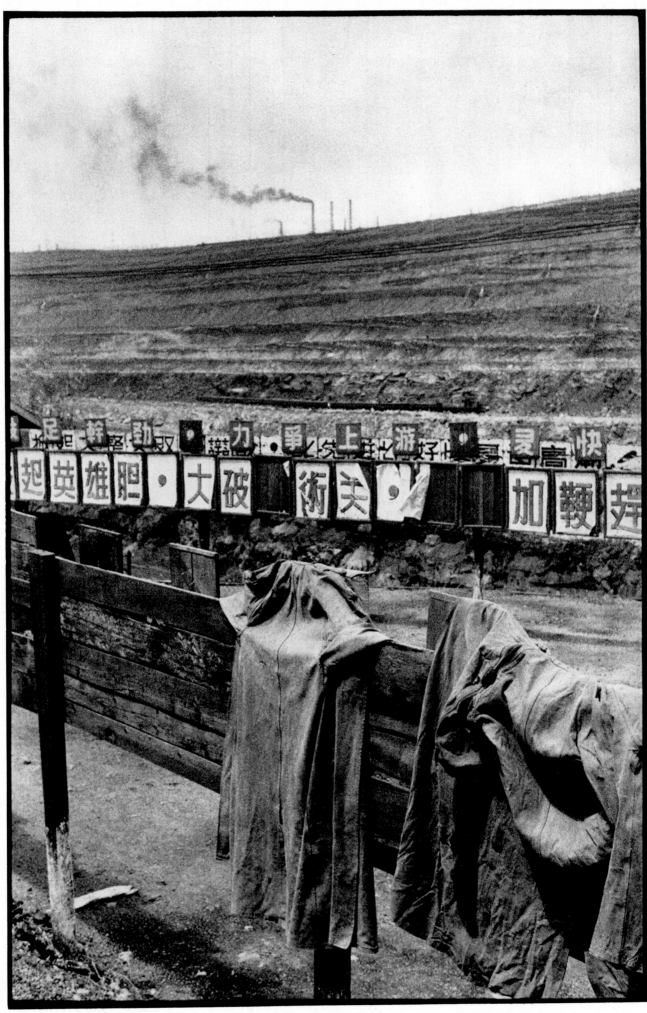

Coal Mines, North China, 1958

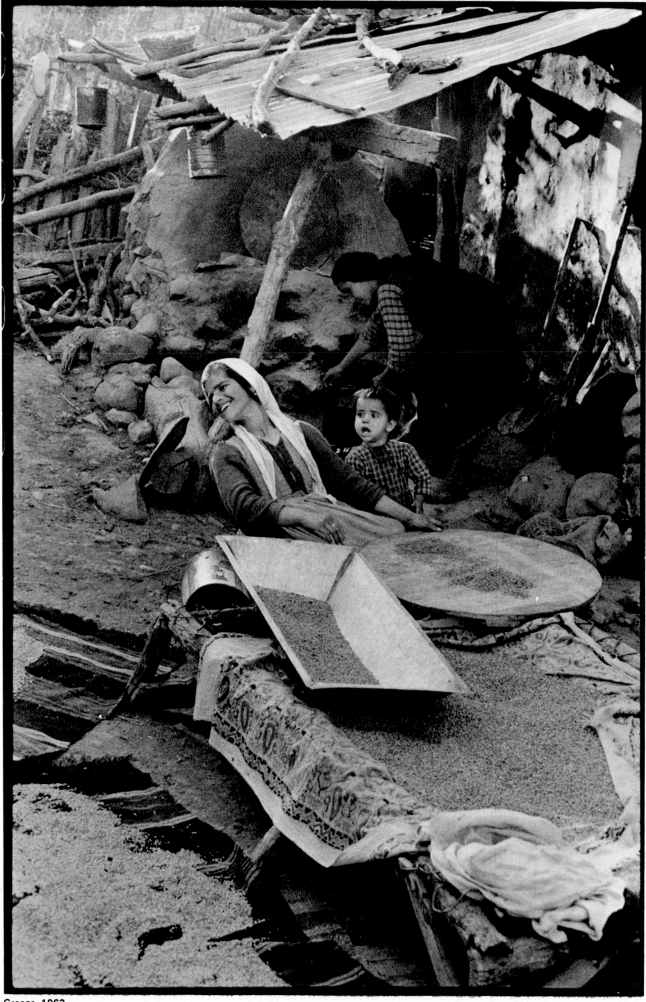

Greece, 1963

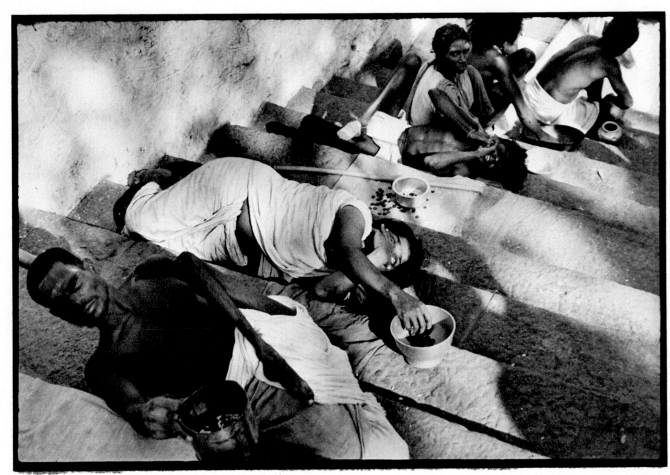

South India, 1960

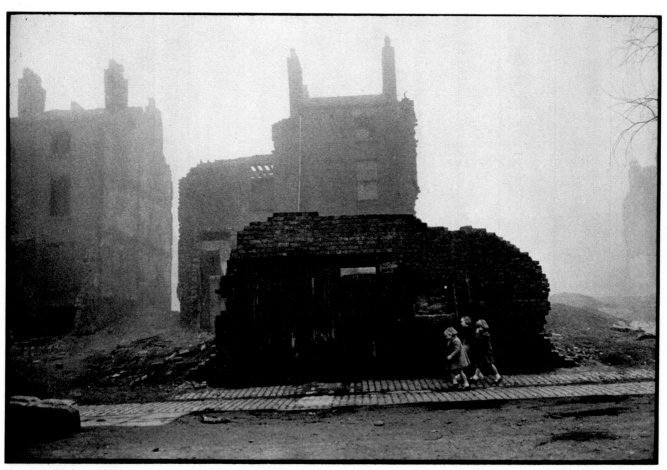

Liverpool, England, 1963

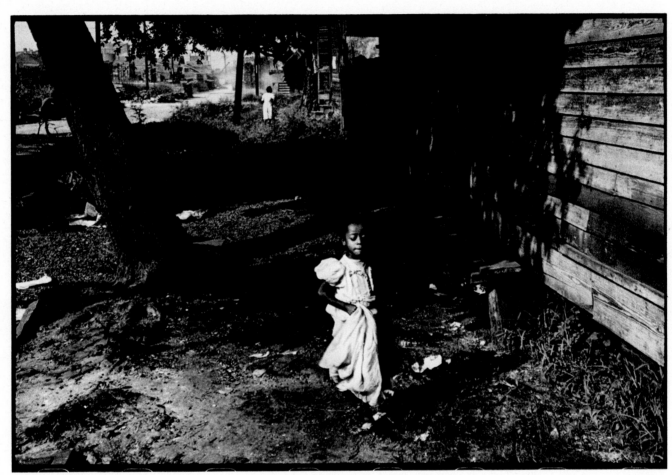

Louisiana, USA, 1946

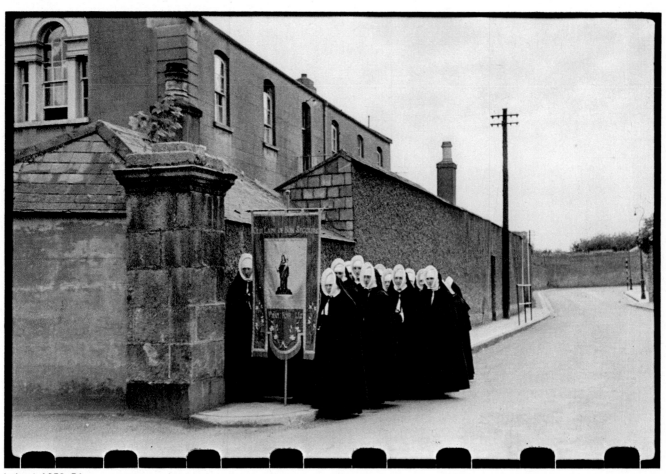

Ireland, 1953–54

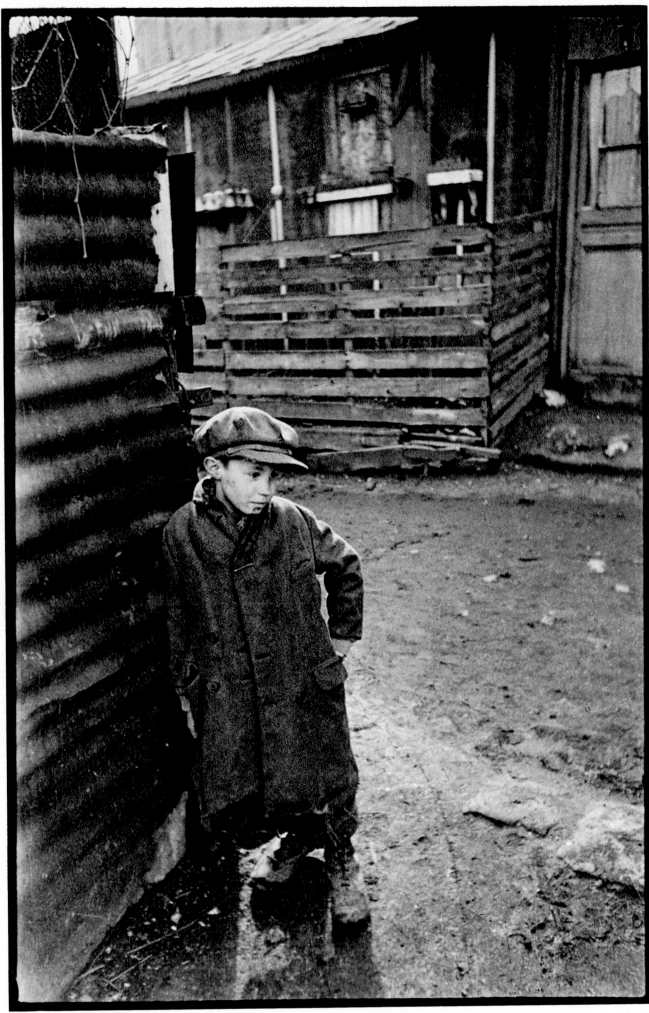

Aubervilliers, Paris, 1932

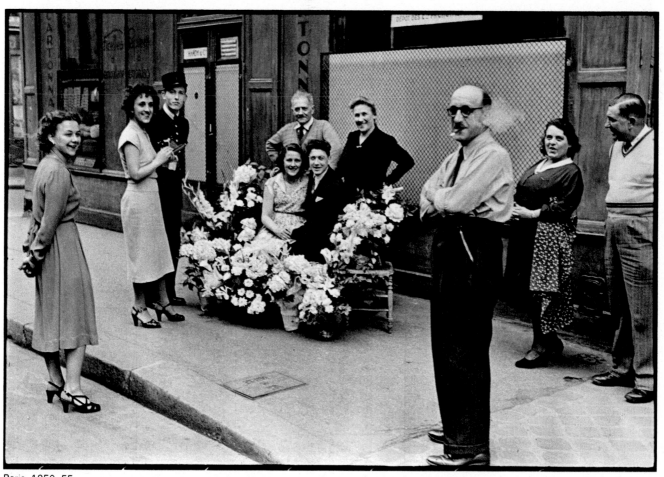

Paris, 1950–55

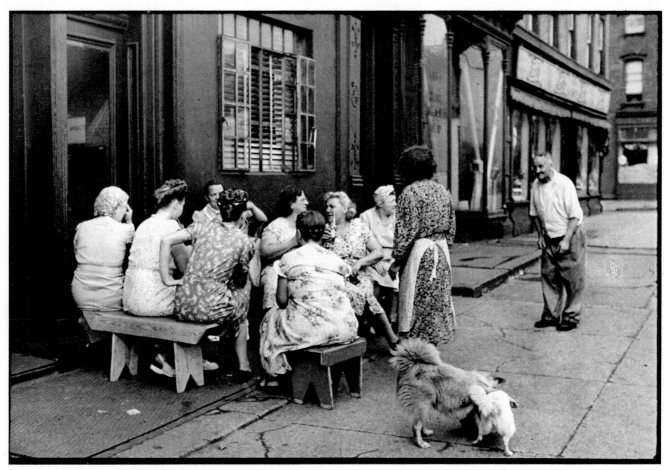

New York, 1946

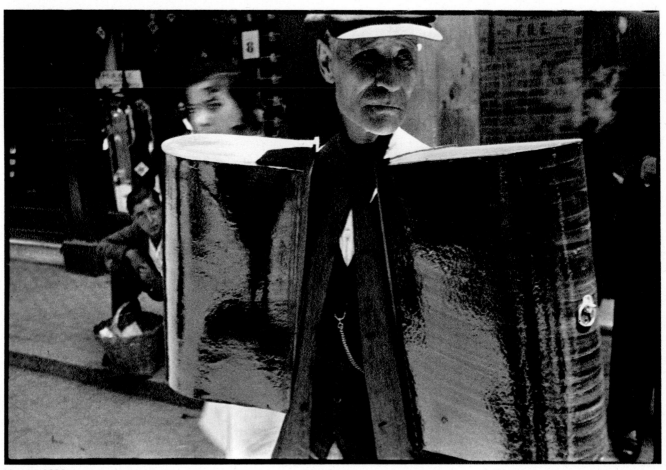

Madrid, 1933

Mexico, 1963–64

Dublin, 1954

Los Angeles, USA, 1946

Beance, France, 1958

King George VI visits Versailles, 1937

Near Rome, Italy, 1962

Eton, England, 1962

Castille, Spain, 1964

Yugoslavia, 1965

Rome, 1954

Budapest, Hungary, 1931

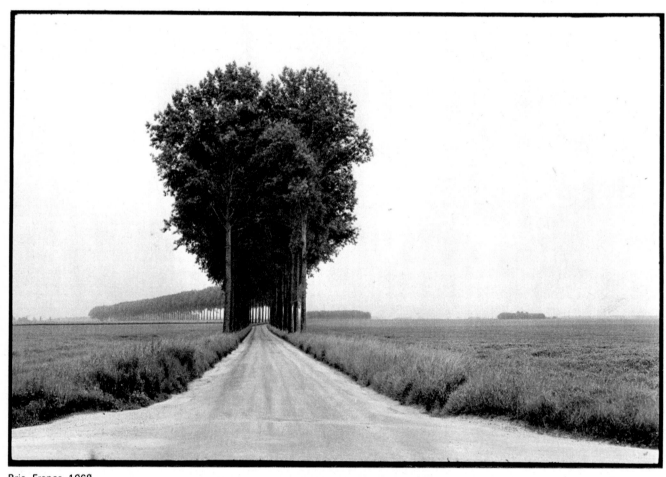

Brie, France, 1968

RALPH GIBSON

Quadrants

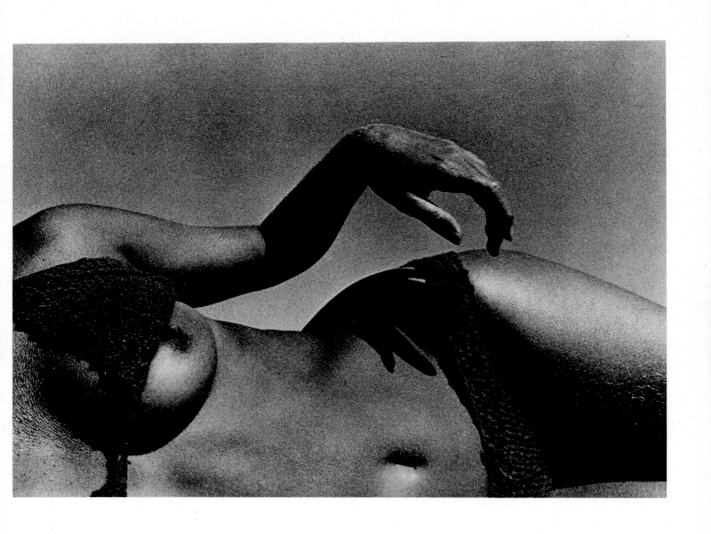

36

CHRIS KILLIP
Isle of Man Portfolio

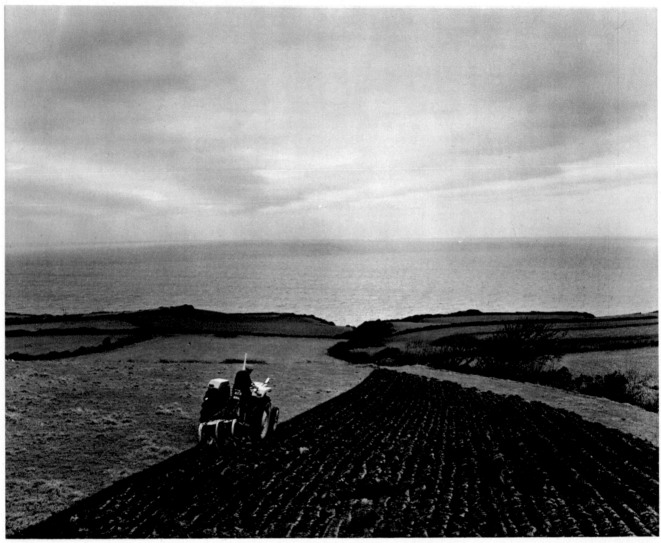

Man Ploughing, Dalby

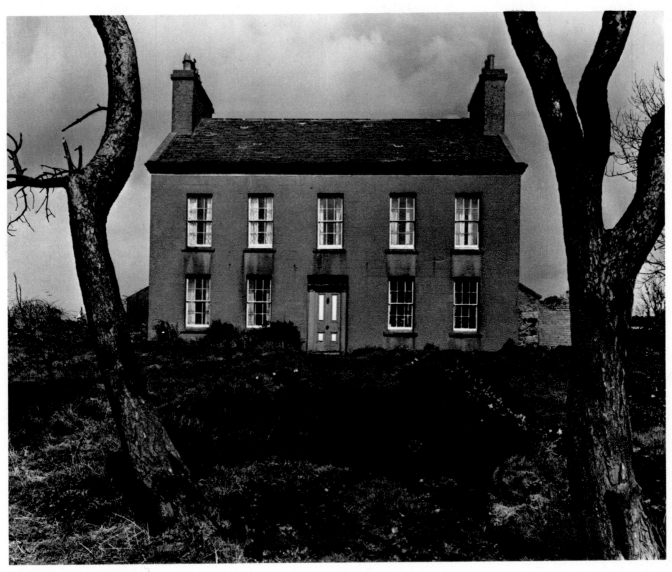

Ballakiel Farmhouse, Andreas

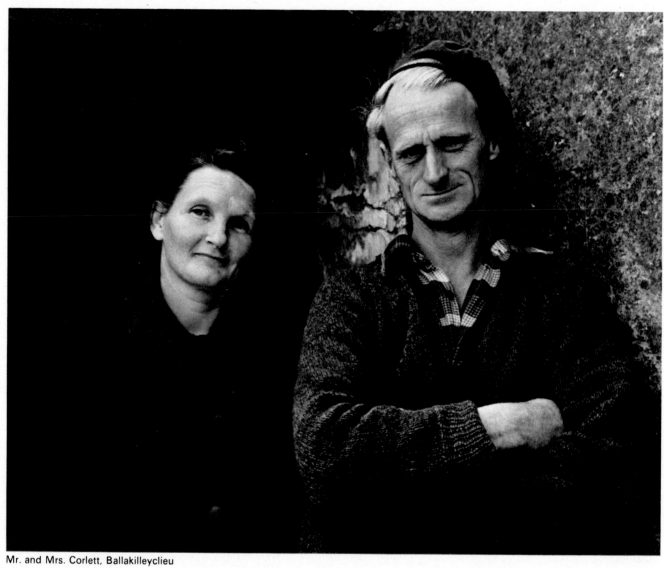

Mr. and Mrs. Corlett, Ballakilleyclieu

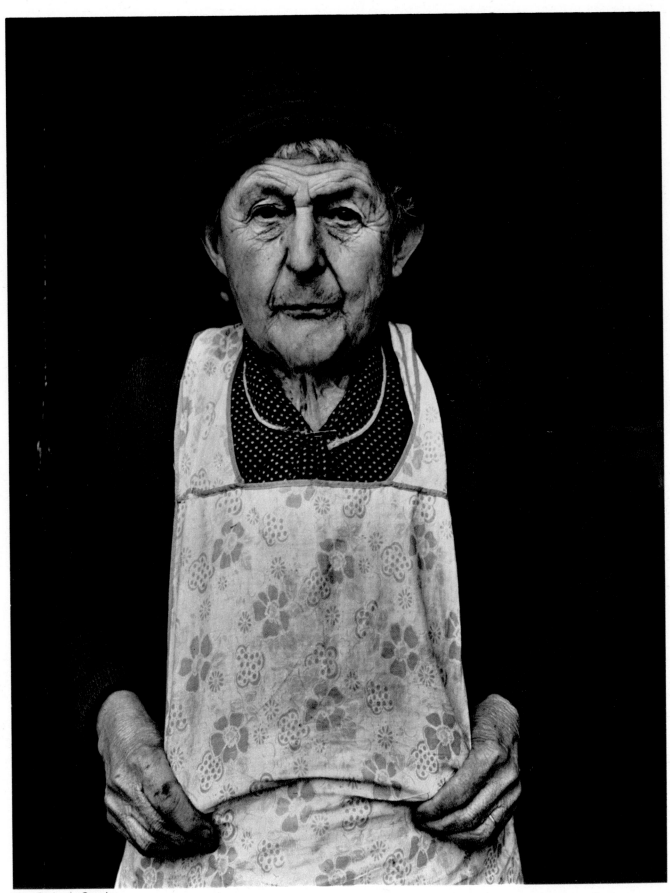

Miss Redpath, Regaby

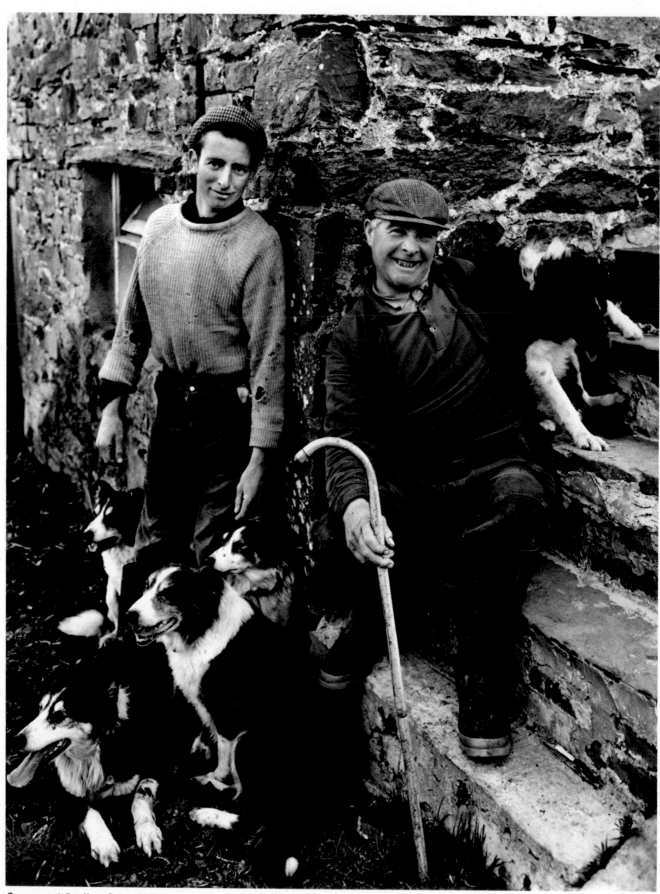

George and Geoffery Quirk, Ballaquine

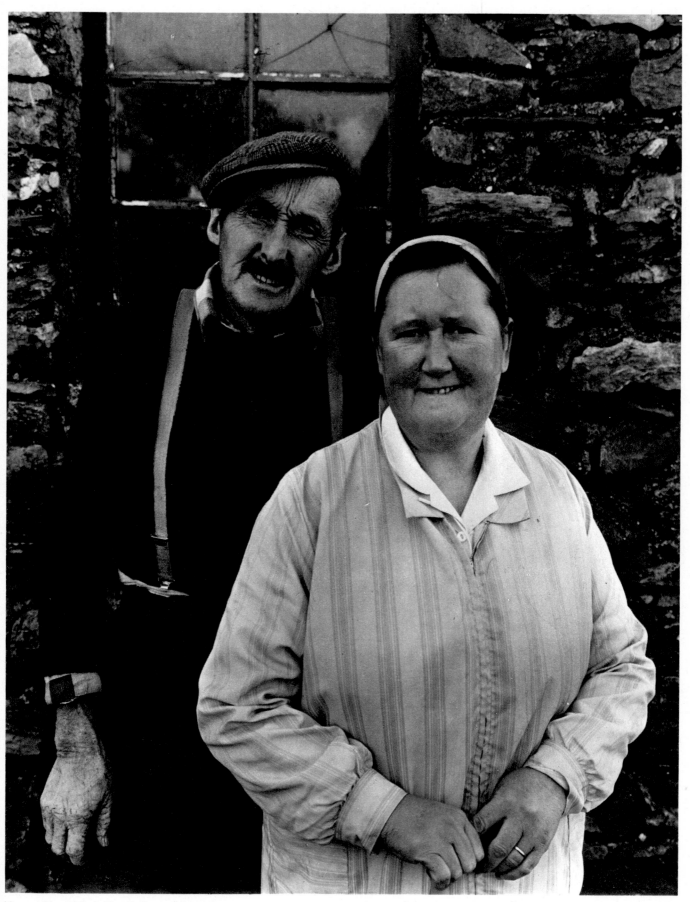

Mr. and Mrs. Mylroi, Church Farm, Cregneash

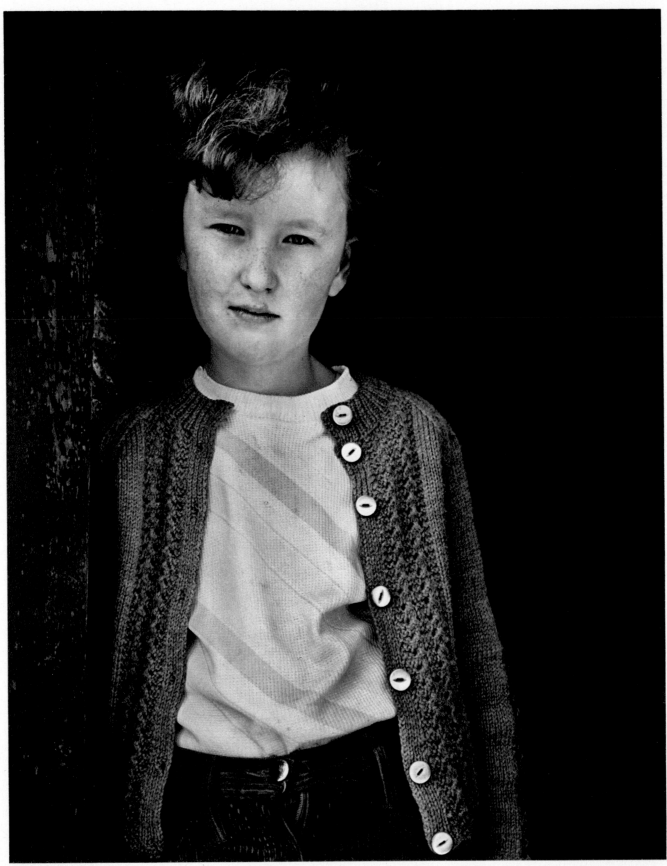

Susan Hyslop, Ballachrink

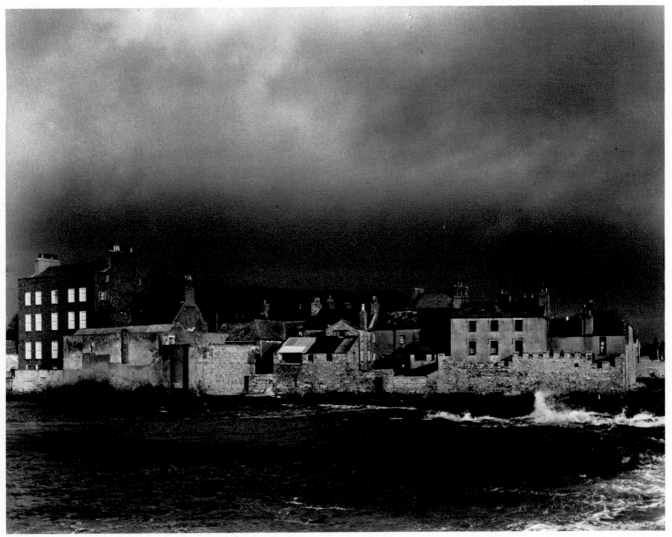

Castletown

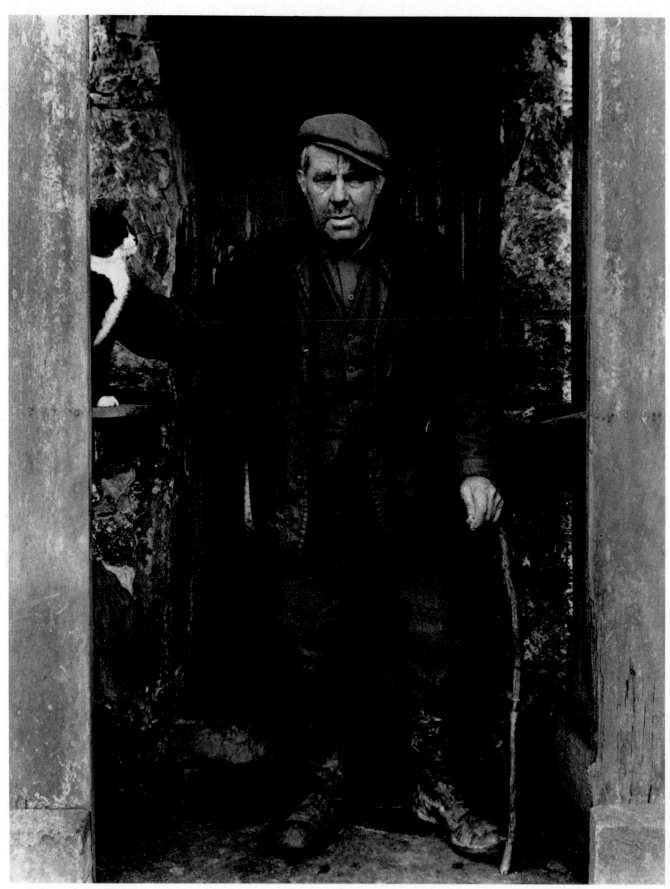

Mr. Raddcliffe, The Blackhill

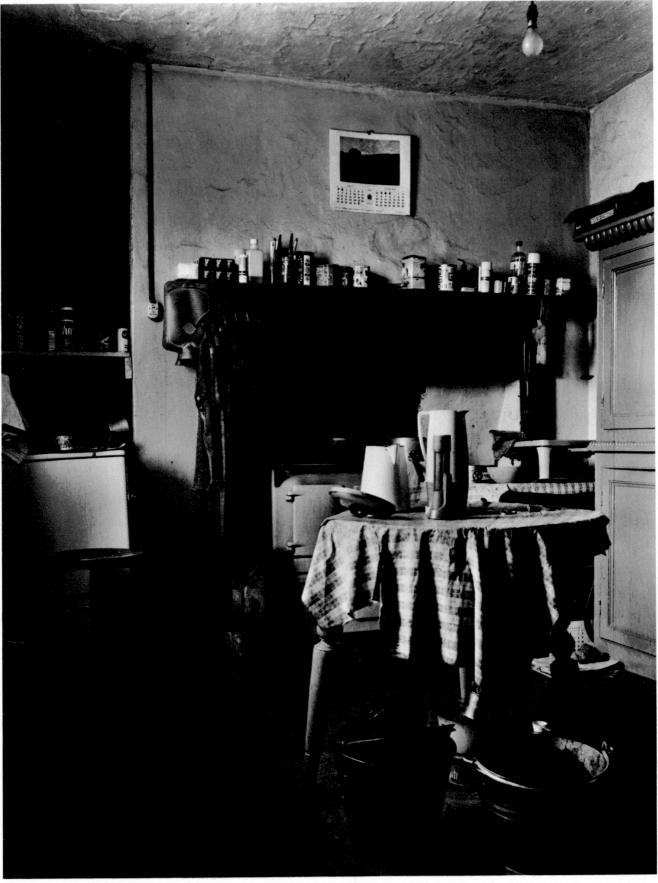

Kitchen

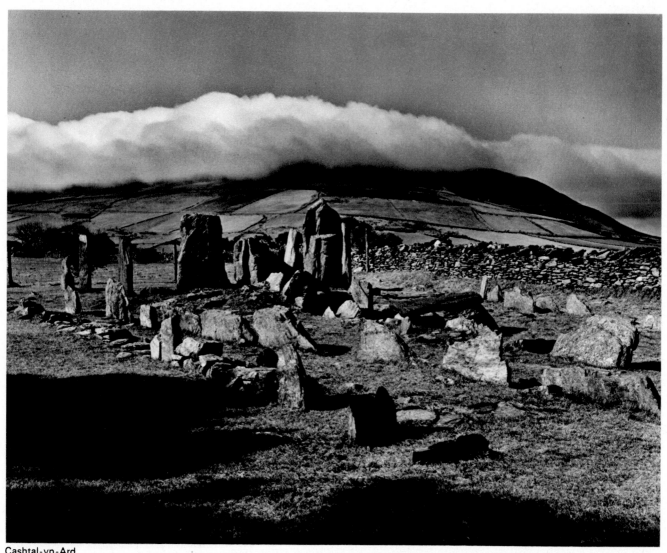
Cashtal-yn-Ard

St. Luke's Church, Baldwin

LES KRIMS

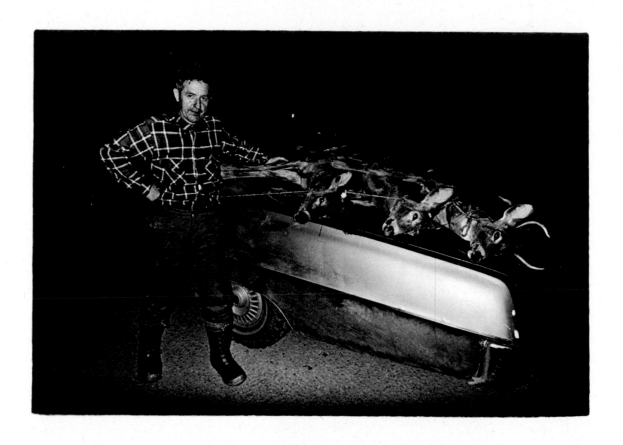

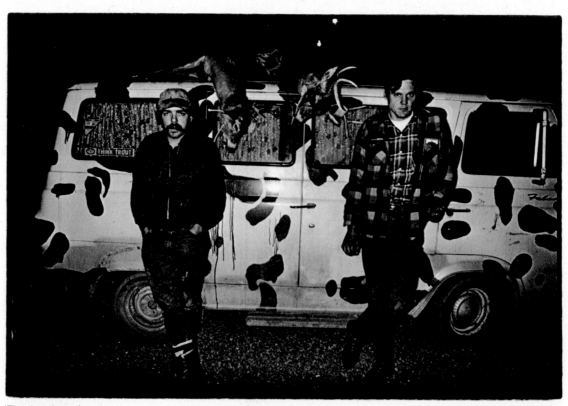

'The deerslayers'

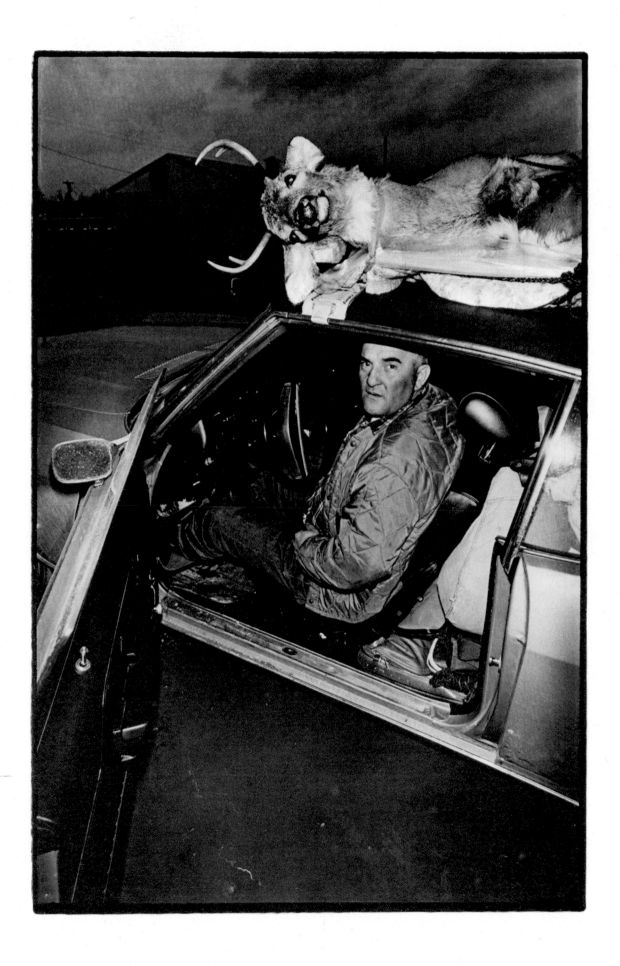

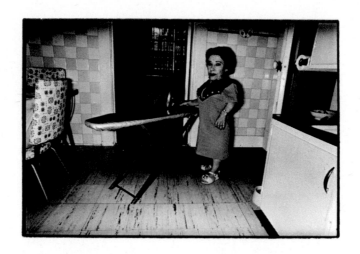

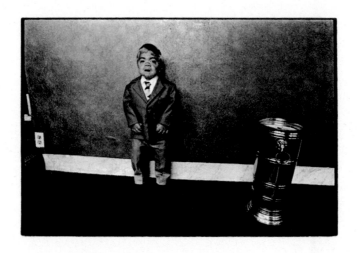

'The Little People of America'

'New Little People'

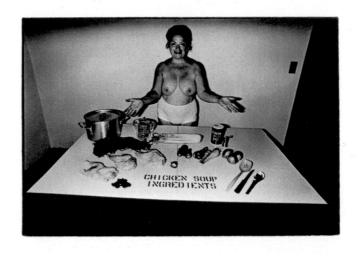

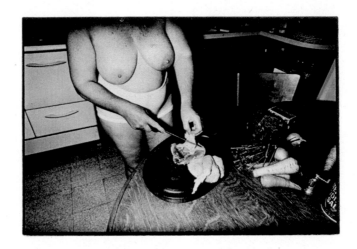

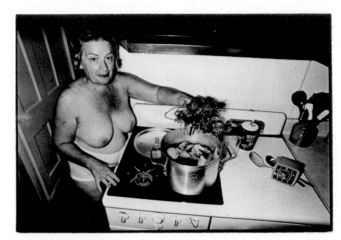

'Making Chicken Soup'

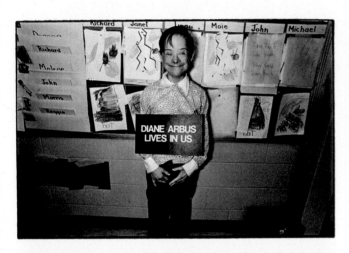
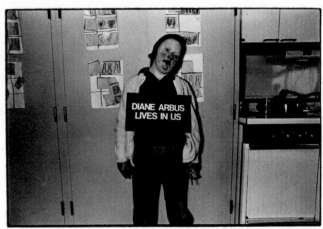
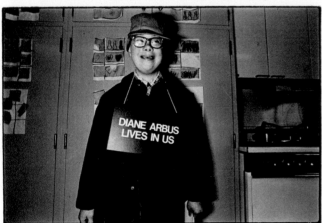
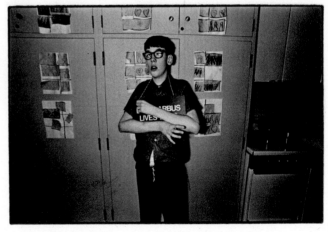

'Diane Arbus Lives in Us'

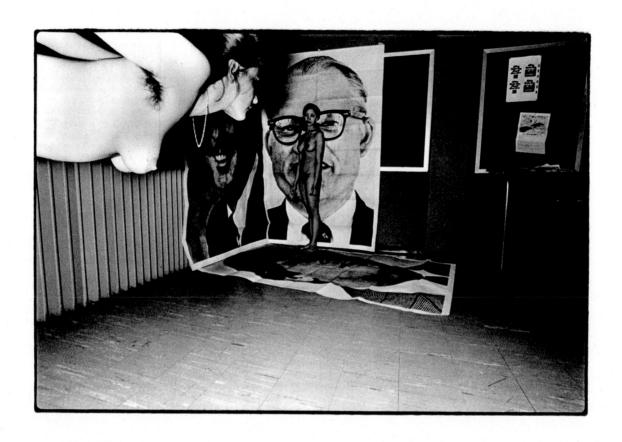

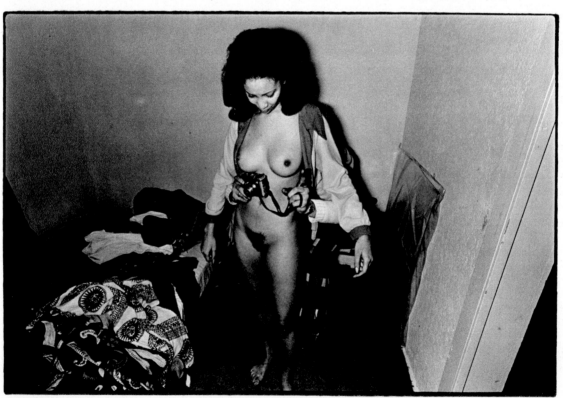

'Class Work'

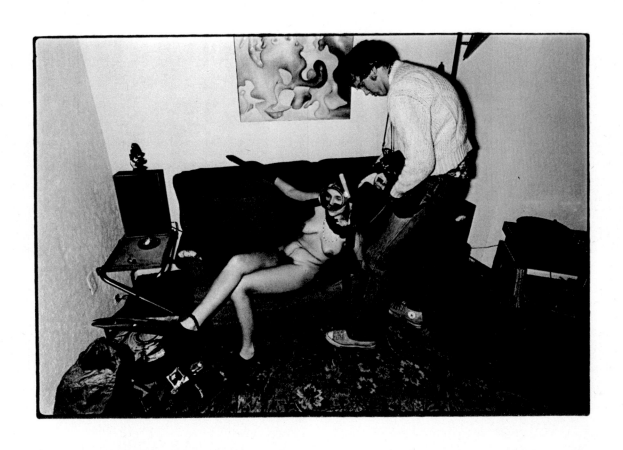

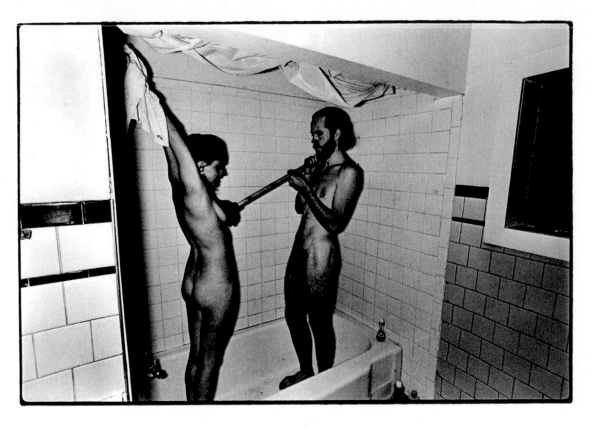

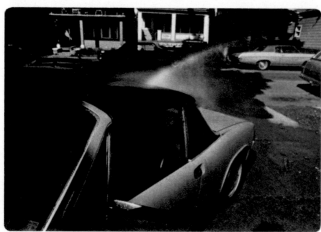
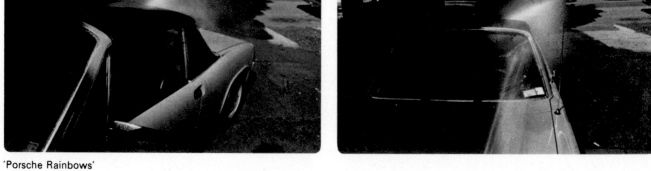

'Porsche Rainbows'

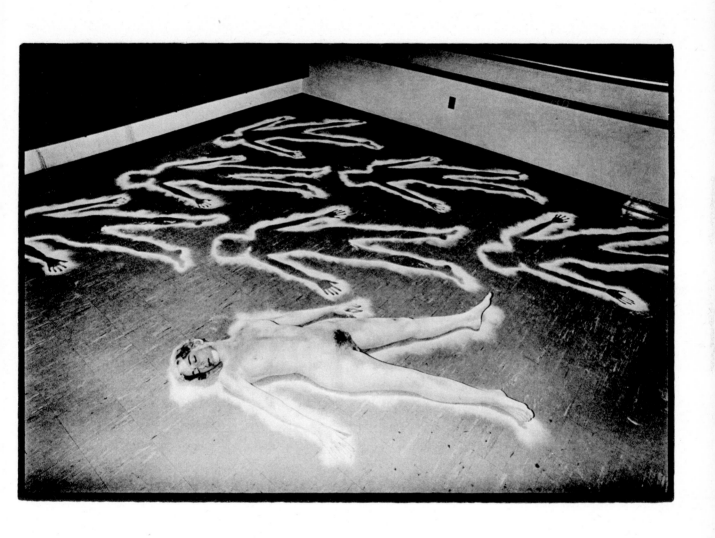

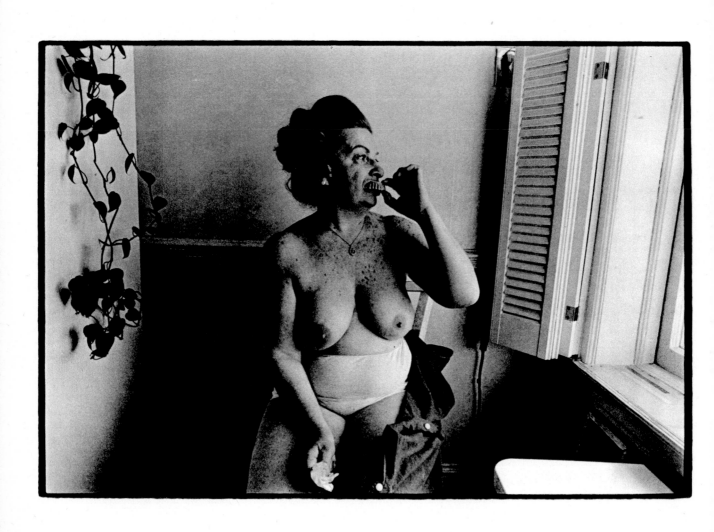

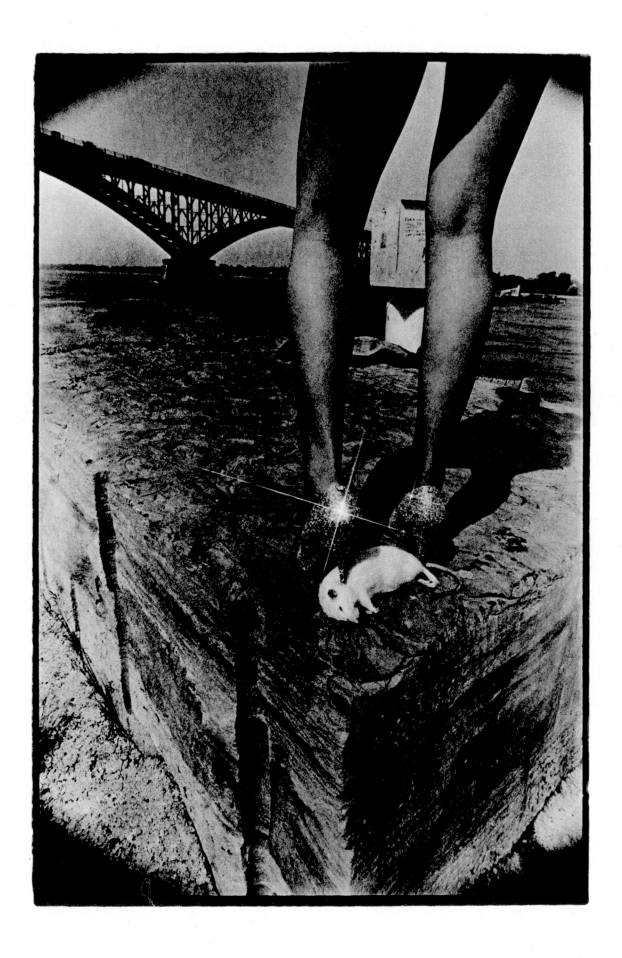

HOMER SYKES

Customs and Traditions

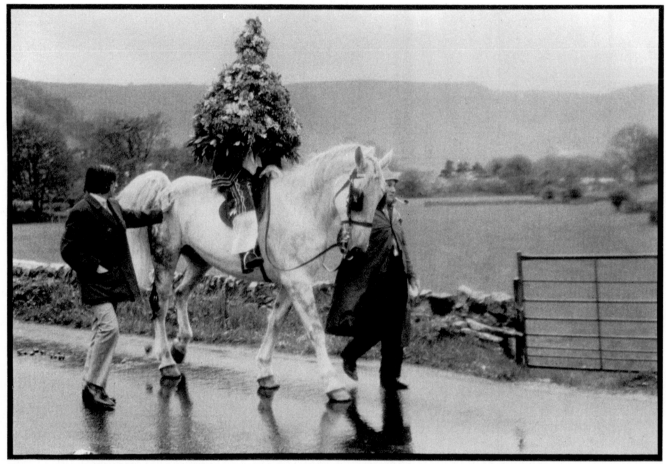

Castleton Garland Day, 1972

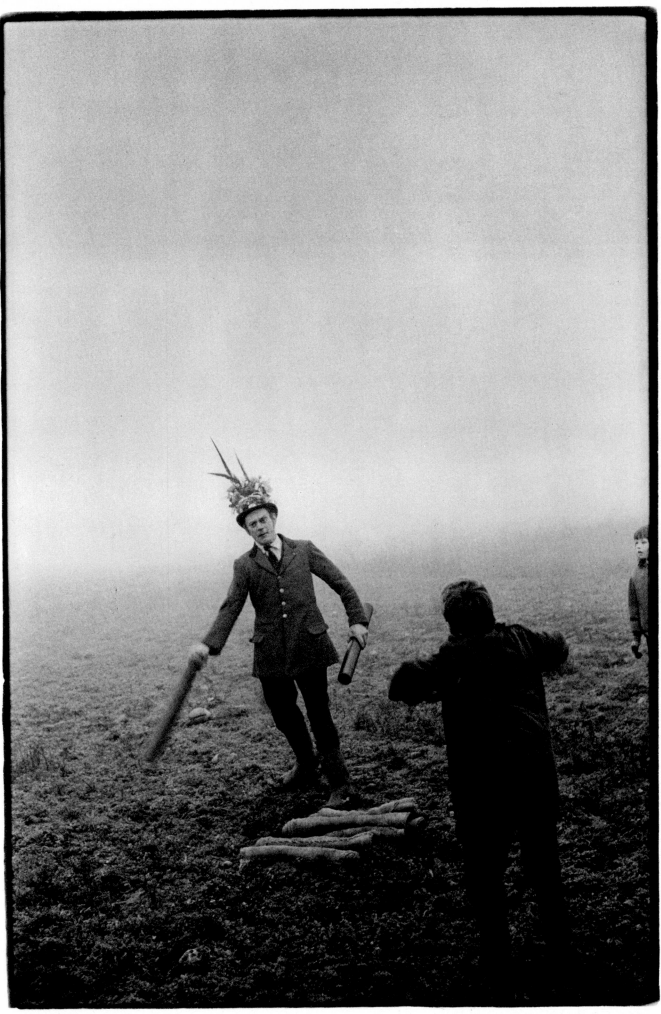

Haxey Hood Game, 1972

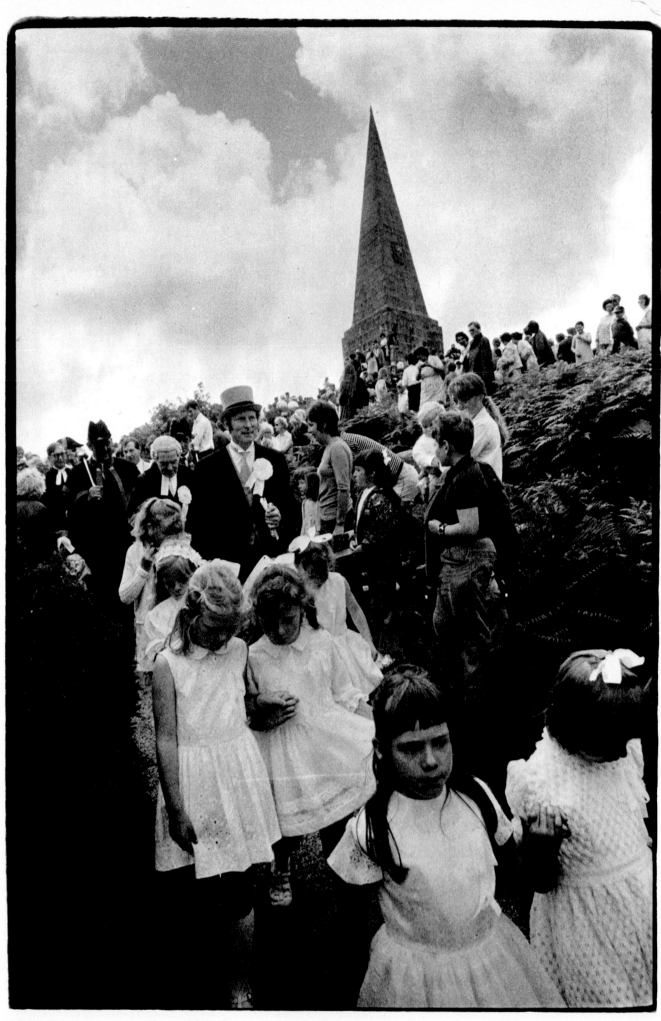

John Knill Ceremony, St. Ives, Cornwall, 1971

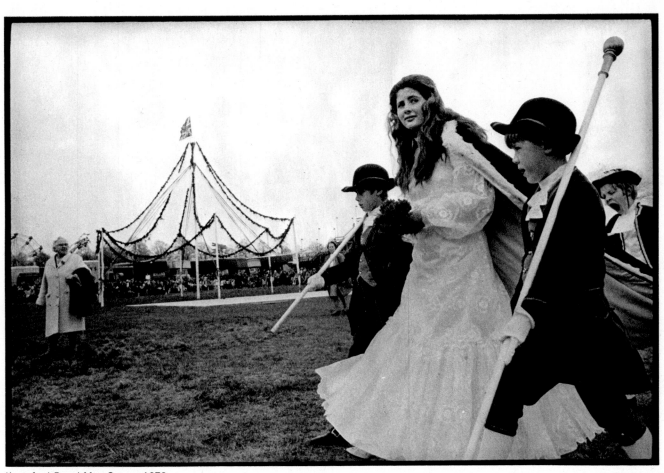

Knutsford Royal May Queen, 1973

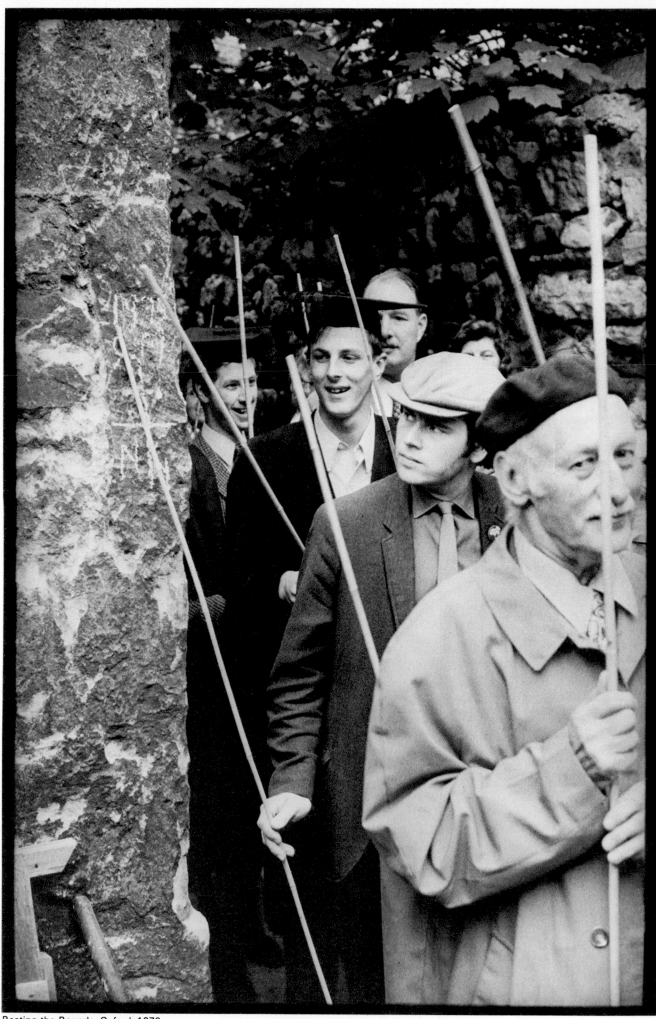

Beating the Bounds, Oxford, 1973

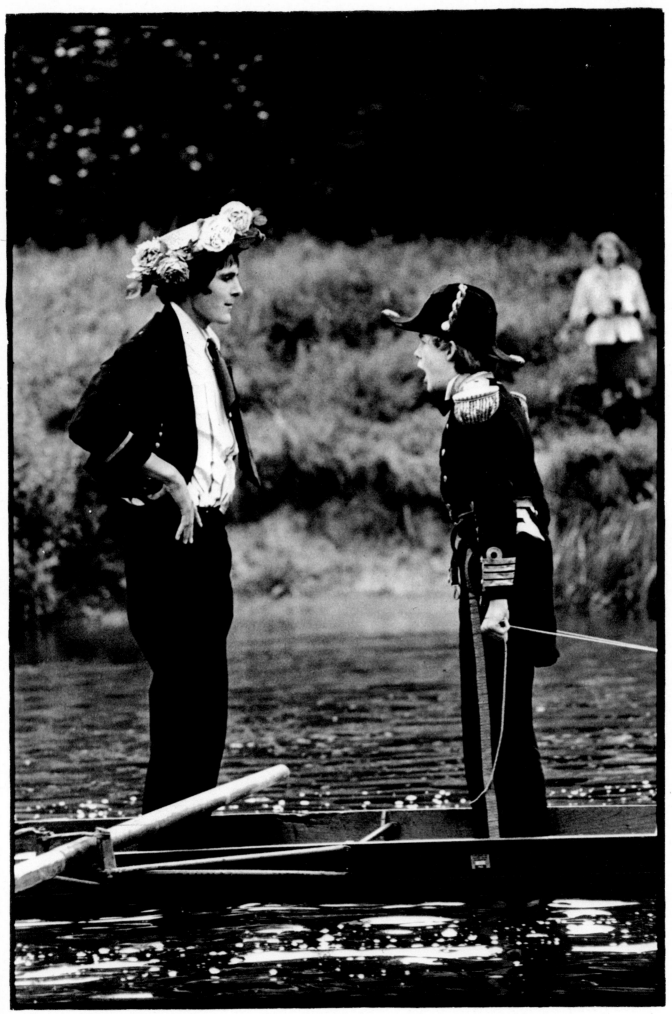

4th June, Eton School, 1971

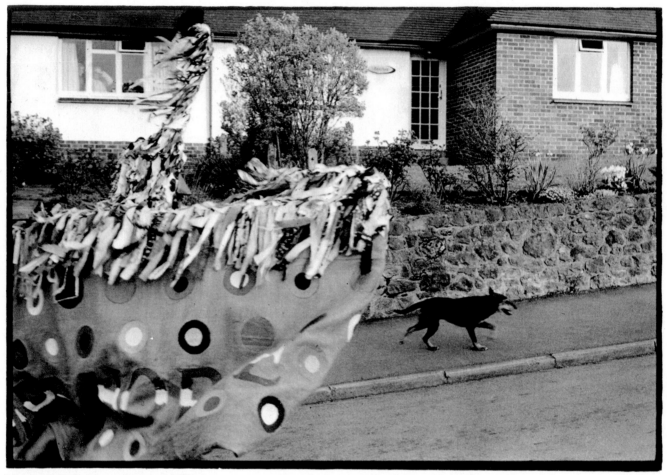

Minehead Hobby Horse, Somerset, 1971

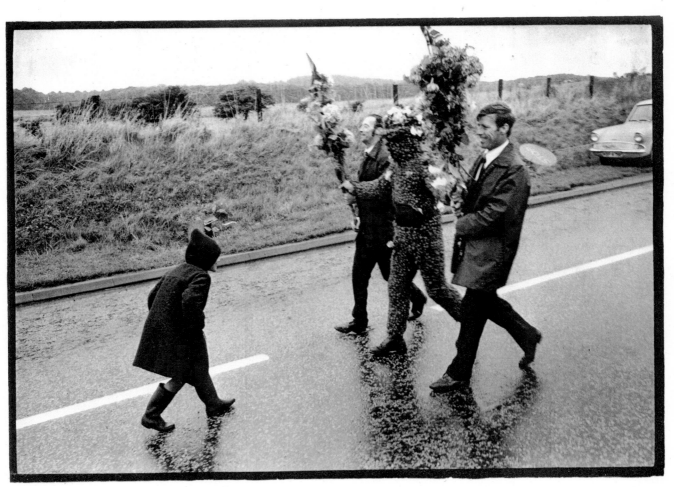

The Burry Man, 1971

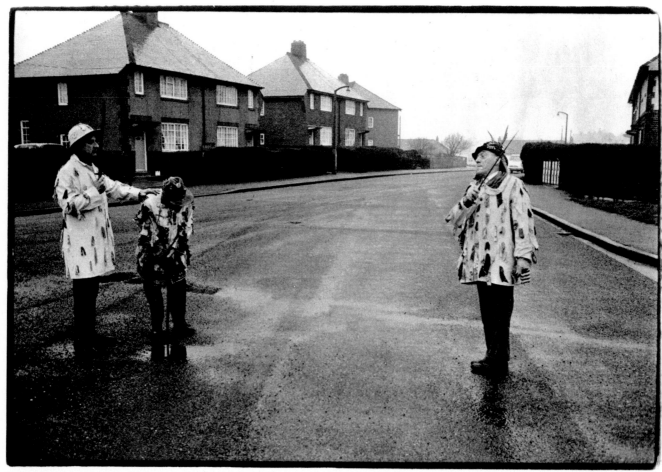

Ripon Sword Dance Play, 1971

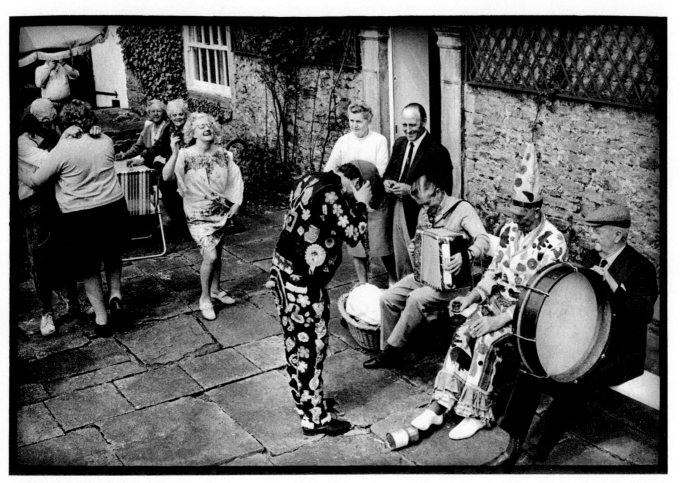

Bellerby, Yorkshire, 1973

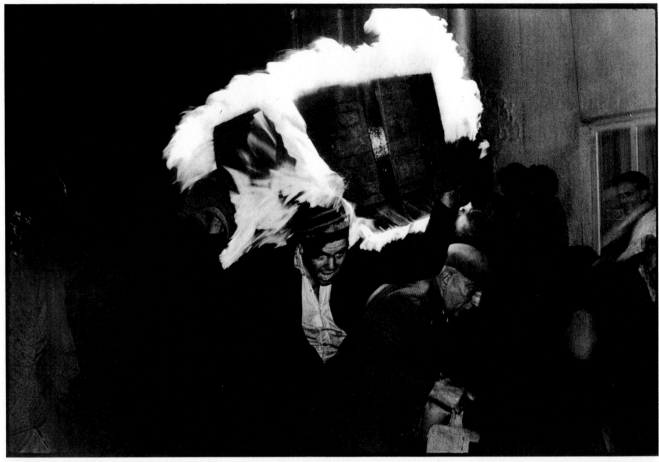

Tar barrels, Otterly St. Mary, Devon, 1973

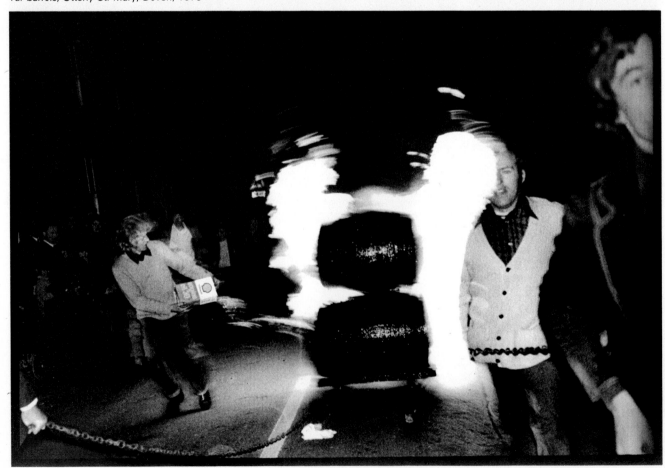

Hatherleigh, Devon, 1973

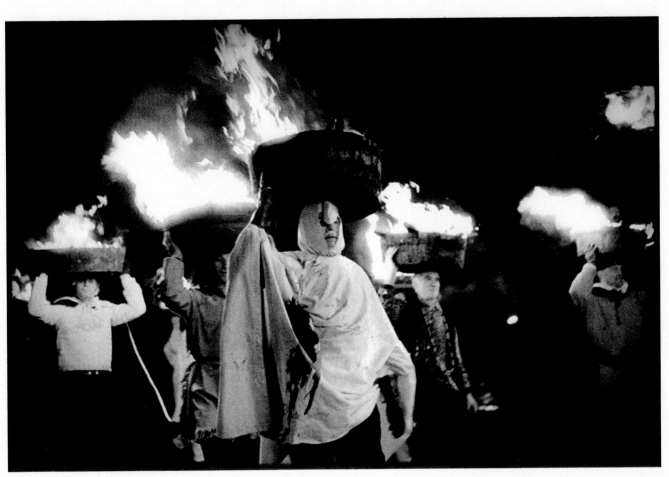

Tar Barrel Parade, Allendale, Northumberland, 1972

Ufton Dole, 1974

"My Camera in the Olive Grove"

Prolegomena[1] to the Legitimization of Photography by the Academy

by A.D. Coleman

The past decade has borne witness to a new and surprising phenomenon: a dramatic increase in the academic acceptance of photography as a serious field of creative and scholarly inquiry, and, as the inevitable corollary thereof, the rise of a photographic academy whose structure, function, and attitudes are analogues (and, in most cases, essentially identical) to current versions of the more established academies within such media as painting and literature.

The prime symbol and crowning glory of this sudden ascension, at least on this side of the Atlantic, was the establishment in 1972 of the David Hunter McAlpin Professorship of the History of Photography and Modern Art at Princeton University. That segment of the photographic community which is still caught up in the battle for photography's recognition as a "legitimate" art form has taken great satisfaction from this specific development and the larger iceberg it implies.

Certainly, on a ritualistic level, it is a formal vindication of Alfred Stieglitz, his apostles and descendants, and their years of struggle to win a place for photography within the charmed inner circle of the "high" arts. (That the man for whom this $1-million chair was custom-built—Peter Bunnell, former curator of the Museum of Modern Art's Department of Photography—wrote his doctoral thesis on Stieglitz adds an appropriate symmetrical fillip).

Such an unexpectedly warm welcome is naturally intoxicating. Yet, after more than a century of academic scorn as the illegitimate offspring of the sciences and the graphic arts, it might be wise—if only on principle—for the photographic community to be somewhat less eager and more cautious upon being clasped to the bosom of the aesthetic nuclear family.

To have "legitimacy" thus instantly conferred is at best a mixed blessing. For anyone who takes photography seriously, it is of course gratifying on one level to witness an increased attention to the medium from art critics, galleries, museums, collectors, and institutions of higher learning. On another level, however, acquiescence to the elevation of photography from the ranks of the "low" arts tacitly affirms the validity of a hierarchy among the arts.

This peerage is a hoary construct, deeply rooted in capitalistic premises. Its fundamental principle is an aristocratic one: that a medium's stature and significance are not to be gauged on internal qualities—*i.e.*, the calibre of the work done within it by its exponents—nor on such work's effect upon the external world, but are instead proportional to that work's financial worth, inaccessibility, and lack of functional utility. The high arts, after all have always been those which only the leisure class could afford to pursue.

For those of us who are seeking the elimination of this archaic, elitist concept of art, the reaffirmation of that aesthetic stratification with its obvious allegiance to the class system, may understandably be viewed as counterproductive. Photography is inherently a democratic medium and anyone concerned with the cultural shortsightedness which has ensured the accuracy of Moholy-Nagy's frightening prediction[2] cannot help but look askance at a set of priorities which valorizes Mandarin over Cantonese.

In evaluating photography's newly-conferred academic respectability, then, it is important to take note of the implicit premises thereof. "He who controls the definitions controls the structure of society," as Stokeley Carmichael has said; wrapping the mantle of scholary approval around a medium which has received the cold shoulder from birth is surely a significant attempt at redefinition.

Simultaneously, we must look closely at the emerging photographic academy itself, in order to examine the implicit and explicit definitions of photography which it propounds. Photography is a unique medium in many ways, one of which is that it is enormously widespread and highly diversified in its utilitarian, communicative, and creative functions, yet young enough to have developed only a few centralized power blocs. These loci therefore exercise an ability to shape our definitions—and thus our

[1] *"Prolegomena"—preliminary observations on a subject (Ed.)*
[2] *"The illiterate of the future will be ignorant of the use of camera and pen alike."*—Broom, 1923.

culture's understanding of photography—which is quite disproportionate to their age and size.

The new photographic academy is certainly one of these. Paradoxically, to consider its influence at length is to risk extending that influence; yet we can ignore it only at our peril. It is unlikely that it will simply go away.

"I think today you are seeing the beginnings of a very significant decline in the number of photographers who will be producing serious work for the simple, basic reason that their primary economic source is drying up, which is teaching. It's absolutely true. We have no monopoly on it, but we've got a very, very high percentage of our people who are fundamentally in the teaching profession as a vehicle to support what in fact is an art that is not being supported through any other vehicle."
Peter Bunnell, *The Print Collector's Newsletter*, Vol. IV, No. 3, July-August 1973.

Though it may be looser structurally, on a practical level an academy operates in patterns common to such kindred organizations as craft guilds and trade unions.

One of the primary functions of such institutions is to promote the interests of their members by venerating and propagating standards of performance which, not coincidentally, reflect with considerable accuracy the capabilities, work habits, and taste patterns of those who belong to them.

A standard is a goal whose achievability has been proven beyond question. Within an academy/guild/union context, standards proclaim what can be accomplished comfortably and decorously. No such organization has ever propounded standards which could not be met with relative ease by the lowest common denominator of its membership. No goldsmith's guild ever drums out all but the Cellinis. Standards embody the average competence of those who subscribe to and promulgate them.

Such standards are maintained by limiting the number of licensed practitioners and requiring that new licensees be trained by older ones. In guild and union situations, this takes place through the process of apprenticeship: learning to do something the way someone else does it. Until quite recently, this transmission of craft competence was the sole thrust of formalized photographic education.

As a beginning, this was necessary. There were few textbooks—much less organized, coherent programmes—dealing with the problems and issues of creative (as opposed to commercial) photographic image-making. Consequently, the best and often the only sources for relevant information were those few individual master photographers who had pulled together some coherent, communicable modus operandi from their own experience and were willing to disseminate their personal know-how in the classroom.

This was certainly better than no photographic education at all, but it had numerous flaws. One of these was the creation of a star system under which a particular college, university, or art institute would be considered photographically significant not because it had, say, an intelligently-structured and well-rounded programme which gave students a thorough grounding in the history of the medium and all the diverse processes it encompasses, but rather because Harry or Aaron or Minor or Ansel or Jerry was teaching there. To be sure, there's nothing wrong with wanting to know how Harry or Aaron or Minor or Ansel or Jerry "does it", but the leaking of one's trade secrets to (and the infliction of one's taste patterns on) a group of students hardly constitutes a formal educational methodology.

One central issue in photographic education (and, for that matter, in photographic criticism) is the necessity for developing a useful, comprehensive, nonsectarian vocabulary for discussing the expression and communication of ideas, feelings, and perceptions through photographic imagery. The lack of such a vocabulary is among the crucial problems in contemporary photography. It was surely perpetuated by the star system, which encouraged students to mimic the dialect of one or another individual image-maker, instead of evolving a mother tongue for them and encouraging proficiency therein. During this period, students from different schools often had so little in common that they could not even discuss their differences profitably. This problem has been and continues to be compounded by inarticulate photographer-teachers who delude students into the false belief that verbal incompetence and illiteracy are a photographer's badges of honour.

Nevertheless, one can also point out some highly beneficial results of this apprenticeship system. The general level of craftsmanship among students of creative photography rose markedly across the board during that stage in the growth of photographic education, and it also spread much more widely than might have been expected, due to an explosion of interest in studying photography which began in the early 1960's.

This is not the proper place to trace the causes of that upsurge, which are multiple and complex, ranging as they do from increased affluence among the young to Michelangelo Antonioni's film "Blow-Up". Suffice it to say that during that decade colleges, universities, and art institutes across North America added new photography departments and expanded extant ones. This in turn created a booming market for teachers of photography, fostering the illusion that anyone with a Master of Fine Arts in creative photography could always "fall back on teaching" to support him/herself.

When the economic bubble burst at the beginning of the 1970's, many of these young photographers found themselves redundant. The job market in teaching creative photography began to dry up, the competition became stiffer, and the ability to make personal images, even interesting ones, was no longer enough to guarantee one gainful employment in some school somewhere.

Those schools now hiring teachers of photography are in a position to pick and choose, so they are beginning to require credentials beyond a camera, a portfolio of prints, and a sheepskin. Generally, they are coming to expect applicants to be adept at all the various photographic processes, old and new, even if they didn't employ such means in their own work. Increasingly, they expect candidates to have enough of a background in the history of photography to teach that subject as well. Often they require some training in teaching, which is a craft in itself. And, as a more interdisciplinary approach to photographic education at last begins to flower, schools are starting to sift through the mass for those who are able to teach photography not only as a means of introspective self-expression but as a major language form—one whose communicative effectiveness can be of value to students from such diverse disciplines as sociology, history, and psychiatry.

Naturally, this puts the squeeze on those who are really only in it for the money, a fact which Peter Bunnell bemoans in the statement quoted above. I feel quite differently about it: the last thing photography needs, at this point or any other, is a generation of students whose instructors viewed teaching not as a calling but as a sinecure.

Whichever of these attitudes one agrees with, the fact is that photographic education is currently metamorphosing from the guild-derived master-apprentice relationship to the professor-scholar symbiosis of the academy, and that this is occurring at a time when there is an unprecedented demand for photographic education but an oversupply of would-be teachers.

Under such circumstances, any association whose imprimatur is convertible to heightened employability and/or job security is in a position of power. With such power comes politics.

"It seems to me that the time when the artist could enjoy the luxury of being innocently, or ar least privately, influenced by an art not his own or a variety of other experiential forces is long past. . . . Artists now not only admit to but are acutely aware of what they once only suspected and often avoided; that the central theme of their picture-making is imagery itself."
William Jenkins, "Some Thoughts on 60's Continuum," *Image*, Vol. 15, No.1, March 1972.

". . . throughout the history of art it has been art itself—in all its forms—that has inspired art. . . . today's photographs are so geared to life that one can learn more from them than from life itself." ,
Van Deren Coke, *The Painter and the Photograph*, 1972.

What differentiates an academy from a guild or union is that the academy concerns itself with transmitting not just craft competence but ideas as well.

It is precisely in this regard that an academy always poses a threat to the medium it nominally represents. By definition, the purpose of an academy is to formalize the history of its medium by the analysis, annotation, and codification of that medium's traditions. But traditions, by definition, cannot be thus regimented and reduced to formulae. As John Szarkowski has written, artistic tradition "exists in the minds of artists and consists of their collective memory of what has been accomplished so far. Its function is to mark the starting point for each day's work. Occasionally it is decided that tradition should also define the work's end result. At this point the tradition dies."[3]

Once an institution such as an academy becomes the source of reference point for the traditions of a medium, those traditions become fixed, immobile, and begin to lose

[3]*Looking at Photographs; 100 Pictures from the Collection of the Museum of Modern Art, 1973.*

their vitality. They cease to operate as traditions and instead are converted into conventions.

Conventions, like standards, are embodiments of competence. But creativity and competence are often incompatible with each other. This is not to say that incompetence is a virtue; but, from a creative standpoint, a state of acompetence is often a necessity. Competence, after all, directs its possessor towards the duplication of what has already been done via the employment of time-tested, foolproof procedures. Creativity, on the other hand, is a form of acompetence aimed at generating that which has never before existed and which therefore has no pre-set rules to guide its making, no extant model by which its success or failure can be measured. Creative activity is essentially anarchic, incorporating accident, risk, innovation, abnormality, change.

An artistic academy is therefore almost always a contradiction in terms. Conservative by nature, devoted (like all institutions) to stability out of self-preservation, an academy seeks to maintain the past in the present by moulding the present with the past. Such an organism, whose phase is predominantly entropic, is automatically at loggerheads with its medium's avant-garde. For it is always they who are disregarding and/or deliberately violating their medium's history and traditions, breaking through the boundaries on the academy's maps in order to keep their medium alive and growing. Historically, an academy's relationship to the living pioneers in its medium has usually been an antagonistic one, since academies are bastions of conventionalism while subversion of the established order—emotional, aesthetic, political, philosophical, and cultural—lies close to the heart of the creative impulse. Academies tend to be the mausoleums of tradition, as museums tend to be the graveyards of art.

Often there are positive benefits to be derived from the presence of an active academy within the larger context of a living medium. Some of these we are already beginning to reap. Among them are the spread of craft competence; the organization of an informational network, and a consequent increase in the rapidity of communication; the preservation of significant creative works and research materials; an increased attention to the medium's history and development; revitalization of still-viable methods and processes (such as the non-silver processes of the late nineteenth century, which will be newly useful in the silverless late twentieth century); and the power, respect, and money which accrue to academically established media as a rule.

These are unobjectional in and of themselves, but there is a flip side to most of these coins, a price to pay. Overemphasis on craft competence can deaden creativity. A short-circuited informational network of the sort William Jenkins waxes so enthusiastic over can rapidly become inbred and anaemic (a demonstrated tendency of academicized creative activity). Western culture's obsession with permanence and immortality manifests itself in our continual warehousing of the past. The scrutiny of art is isolated from the personal and cultural contexts in which it grew leads to the dry, reductivist formalism of "photographs about photography." And too much time in the ivory tower, as the above quote from Van Deren Coke shows, can convince one that life imitates art—or, indeed, that art replaces life.

Those are some of the risks on the down side insofar as the existence of a photographic academy is concerned. Yet, in considering that eventually it is imperative to do more than merely strike some balance between these advantages and drawbacks. As noted previously, photographic education is at a point of transition. The key problems facing us at this juncture are: the development of a nonsectarian vocabulary: the shaping of a methodology for teaching the fundamentals of visual communication with photography to workers in all disciplines, not only to "art photographers"; and the broadening of the base of photographic education so that photography becomes a tool as basic as writing, taught from grade school on up to all members of our society.

These are not insoluble problems, but they are inarguable priorities. If the new academy can provide assistance in solving them in the most productively visionary fashion possible, then its presence will be a positive factor in the medium's evolution.

If, however, the photographic academy proves to be such deadweight as only a bastion of tradition can be, we might do well to remember that photography has already altered permanently the ways in which we experience our world and understand our experience. Photography has done so entirely without an academy of its own, and often over the active opposition of the larger academic community. Under such circumstances, it would not be ill-advised to retain the option of reverting to bastardy, should that involve losing nothing more than the dubious distinction of the good name of Art.

the
nude
as
human
portrait

That the nude female body has a sexual and erotic importance seems so obvious as to be hardly worth saying but it does bear examination because it is only in comparatively recent years that total nudity has been regarded as erotic for its presumably male viewer. We all know that in Victorian times 'a glimpse of stocking was something shocking' and that men would get turned on by the merest sight of an ankle. Victorian and Edwardian literature abounds with the allure of the veiled woman of mystery. Even the daring and saucy pin-ups of that period seem to us to be surprisingly over-dressed although, as many collectors now find, they have an erotic charm that still survives over the years.

How far this concealment can be regarded as prudery or repression is more the work of social historians but I think, unquestionably, it gave rise to the increase in what perhaps can best be described as deviant eroticism to the extent that the Edwardian age in Britain was regarded as the successor of the 'naughty nineties' in Paris and the envy of the rest of the world not just for its sex life but for its deviant sex life.

There was recently published a book *Victorian Erotic Photography* which showed numerous examples of how the nude was used in photographs. Of course, such a collection is selective and must partly represent the contemporary editor's point of view but much is confirmed by other collections and selections that have appeared in the past. The overwhelming impression that one receives from this mass of pictures is not on the whole particularly erotic, except in the case of some of the particularly direct pictures. These, although lacking almost all aesthetic qualities, can stimulate by their very blatancy and will succeed in doing so because the viewer knows that he ought to be stimulated. The same argument can be used over pornographic material which in spite of its general repulsiveness can succeed because we know that its ostensible intention is to stimulate.

If this was true of the female in Victorian times it is perhaps true of male pin-ups in our present day and there have been successive attempts to produce for females the equivalent of the male pin-up. To date they all seem to have failed in spite of a general feeling by women that they are entitled to their own pin-ups. It would be both impertinent and unwise of me to comment on this but there is a substantial demand for these pin-ups from women who would be regarded as more emancipated than most. The complaint about the 'girlie' pin-up is that it treats woman as a sex object. It would seem illogical to make a reprisal for this to treat the men as a sex object also.

There is an alternative, or in fact several alternatives. The first is to look at the nude as an 'art study'. The phrase has suffered terrible abuse for every first and second rate piece of titillation has probably at one time been called an 'art study' and everyone so titillated, a 'student of art'. Leaving the abuses aside there are, unquestionably, times when the nude photograph can be something other than a naked pin-up. Of course there is a sexual content still there and some may find them more erotic than the actual coarseness of the pin-up. But if an easy distinction has to be made it is surely that in a pin-up it is the subject that is important and in the other sort of photograph, the truly artistic, the flesh is less important than the print. It is the artistry which makes a picture appealing not the person portrayed.

Of course the border lines are blurred; it is difficult to lay down a hard and fast line of where one category begins and one category ends. So much depends on the intention of the photographer and his ability to realise that intention. Regrettably many camera club amateurs never fail to realise that there is a difference and consequently go on making endless banal repetitions that lack the vitality of a good pin-up and the artistry of a good study. The third category is what this thematic section is all about.

If we go back 100 years in the study of health and hygiene we realise how far the world has moved for it is about 100 years ago that people in general began to realise that sunlight and fresh air were good for you. The rich could get their tuberculosis treated in Switzerland, the working class were encouraged to take day trips to the sea where even the incredibly modest Victorian bathing costume was far more exposing than the normal dress. Queen Elizabeth I, it is said, never bathed but the Victorian age was the age of the bathroom and w.c. 'A healthy mind in a healthy body' is what they were taught. Towards the end of the century a few cranks began to suggest that the greater the exposure to sunlight and fresh air the greater the healthiness. Benjamin Franklin can be counted among the precursors of these cranks, but as the century turned, countless more in their flight from urban corruption turned to the cult of the open air. Heliotherapy became an accepted form of nudism and for perhaps the first

time in history the nude was no longer a sex object or an art object but, as hundreds of schoolboys have discovered, furtively thumbing through the pages of pre-war nudist magazines, became all too solid human flesh.

The early history of nudism was coupled with socialism and, come to that, vegetarianism for a number of reasons which perhaps can best be summed up with the idea that they were a flight from the urban life and the flight from the living conditions of those days including even the food they ate. Over all there rested the doctrine, incompletely understood from Rousseau, of The Noble Savage, who the wicked commercial exploiters and misguided missionaries had destroyed. The paradise in which the naked sons of Adam lived was no more. There is plenty of evidence to support this view. Consider the introduction of syphilis to Tahiti; of elephantiasis to the Marquesas; and the physical degradation of the Red Indian, the Aborigine and the Maori. Even today the philosophy can still be heard when we talk of the treatment of the Vietnamese peasant. The idea, be it myth or be it reality, that they were better off left on their own finds other expressions even today among the hippy communes which for a time tried to retreat back to rural self-sufficiency.

From all these influences a new 20th century idea was growing up. New perhaps only because although it had existed before it was rephrased in what seemed an original matter that clothes were more and more a veneer of civilisation. Strip the veneer and you come to the real person. Clothes as symbols of a materialist society and all class distinction should be cast aside for all are equal in Eden. This is not merely philosophy; those who have worked with nude models will know that the removal of the clothes is the removal of a barrier. I add hastily that it is not a prelude to a sexual orgy but that many models, professionally engaged, feel quite uninhibited in telling someone who is a comparative stranger many highly personal details of their private lives. In other aspects one has only to see a lot of modern films to realise that nowadays total nudity is required of any self-respecting orgy if it is to be truly uninhibited.

It is doubtful if any of the photographers featured here would have rationalised their thoughts in this way but what is the common denominator with them all is this striving to expand the themes of nude photography. In general the striving has been towards un-inhibition, not in its simple sexual sense but as the letting down of the defences on the world so that the person portrayed may be seen as he really is both in the obvious physical way but also in psychic terms. In this sense they are portraits.

In others of the pictures the subject before the camera has become less important and it is the personality of the photographer which emerges from the pictures. This was nearly always true of any photograph but in a commercial picture the requirements of the market so smother the photographer's individuality that it becomes unnoticeable. In our pictures because there are no commercial pressures the photographer as well as the model is portrayed and as in a self-portrait the photographer comes through as in a mirror image of the model. In this case perhaps 'model' is too formal a word to use but 'subject matter' seems even more inhuman. This humanity is the great strength of these pictures for out of the apparent randomness in which they are taken and what seems like lack of organisation there comes the very human revelation of one and sometimes two people seeking and sometimes finding the truth of the person. That is the subject matter of all great portraiture.

Colin Osman

Paul Cox

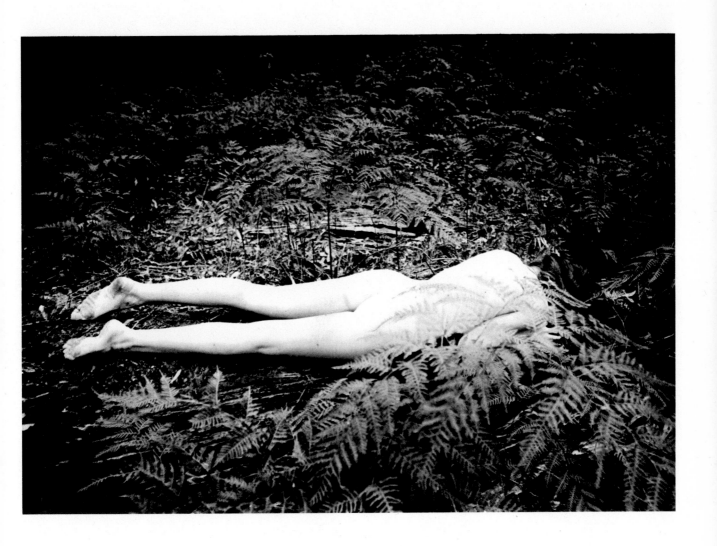

Paul Cox

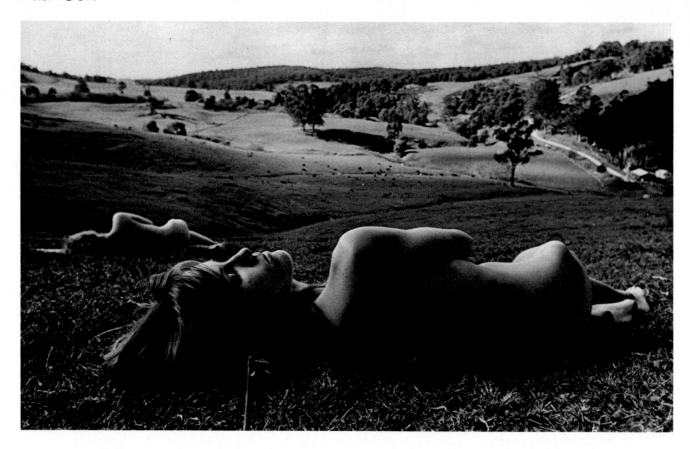

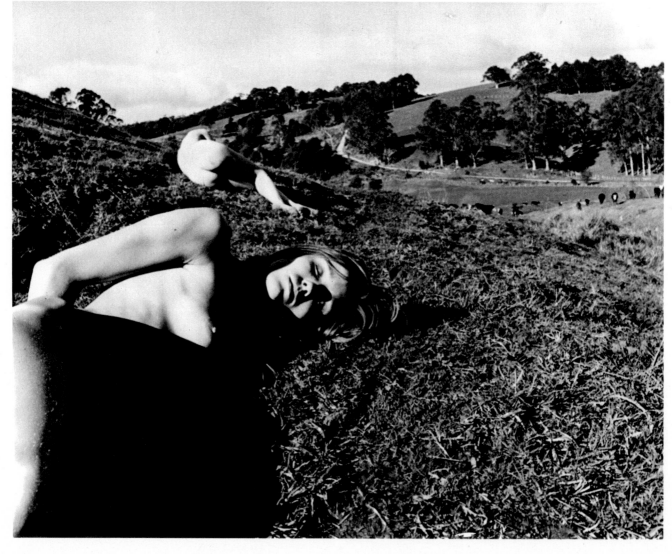

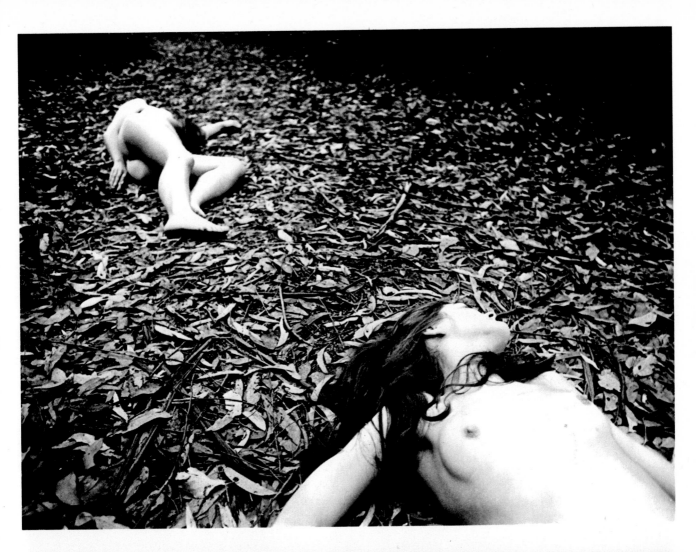

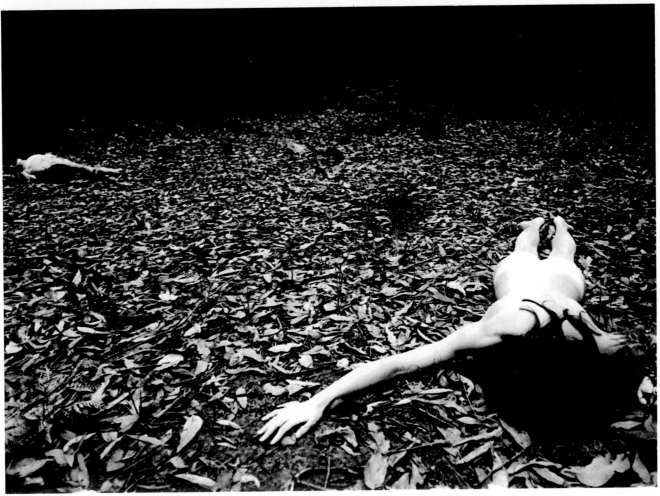

Clifford Seidling

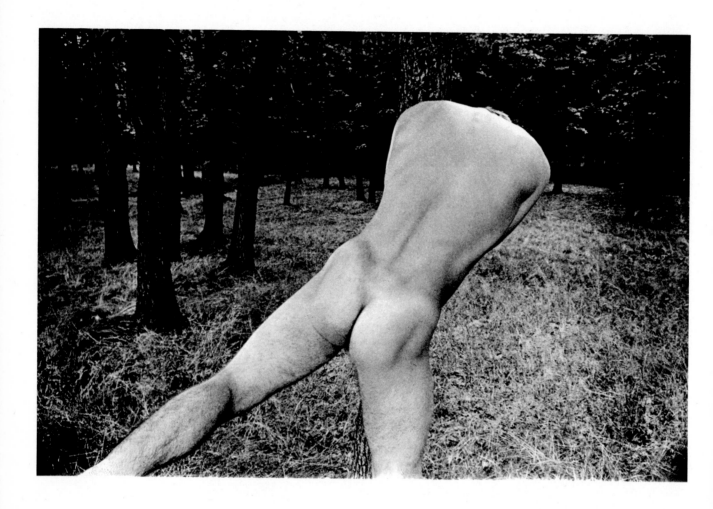

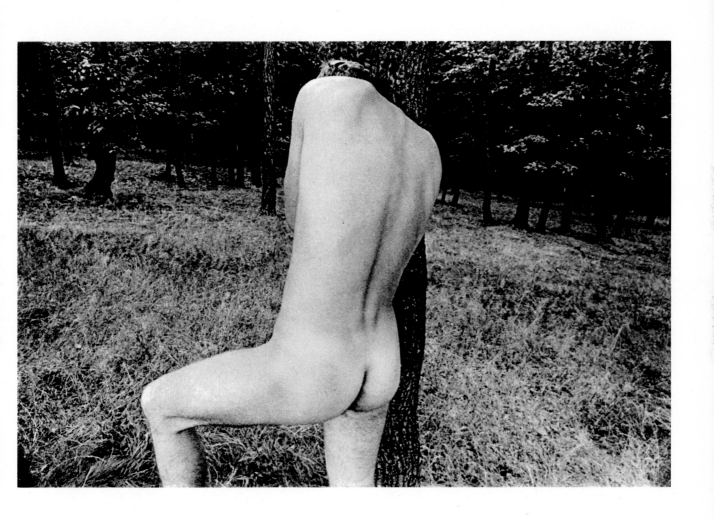

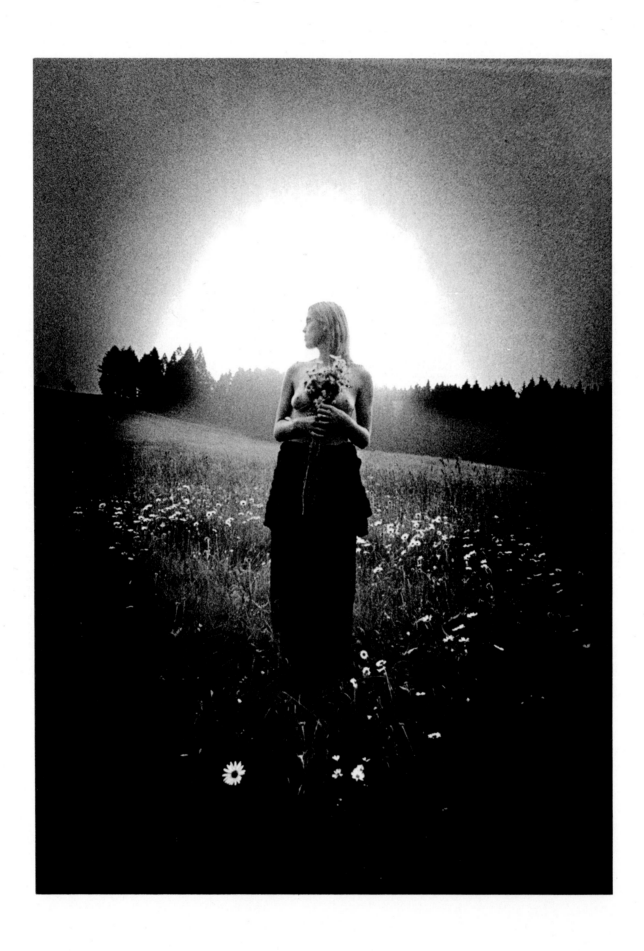

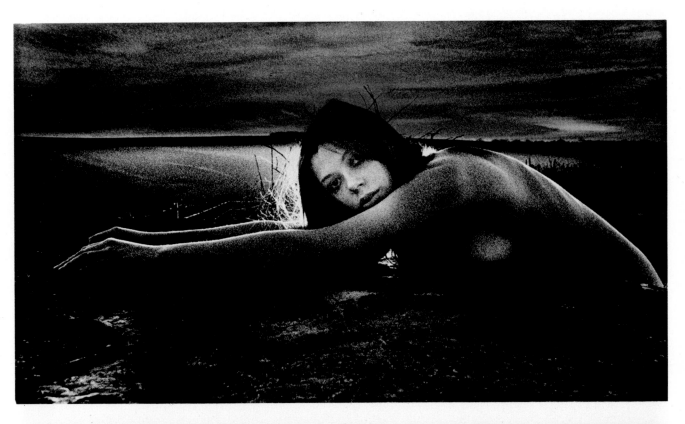

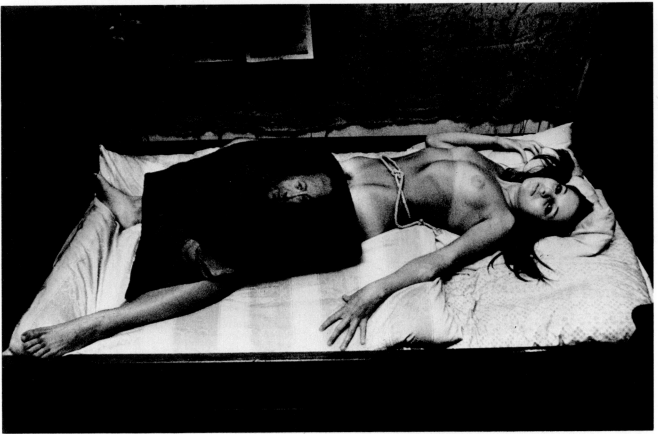

Rostislav Kostal

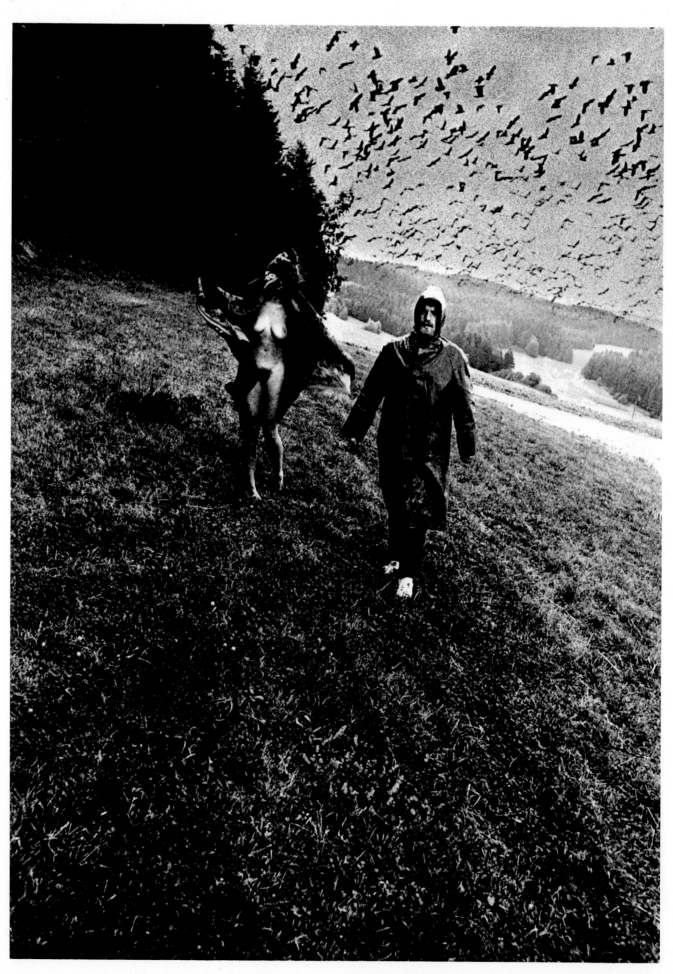

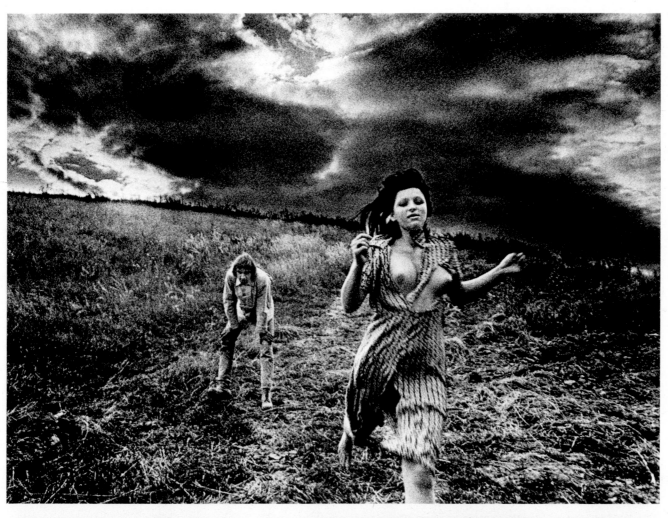

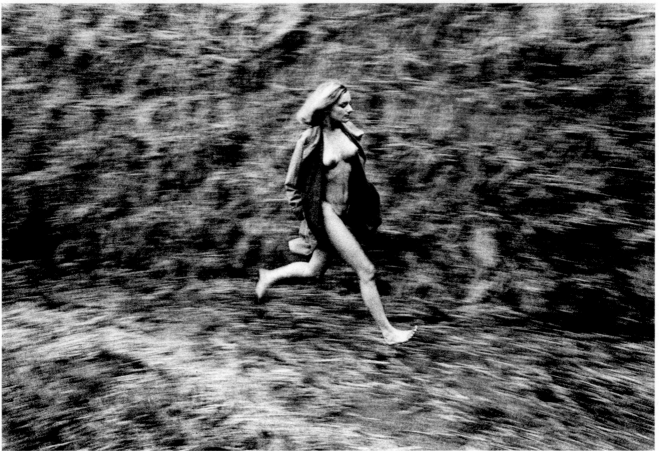

Chris Enos

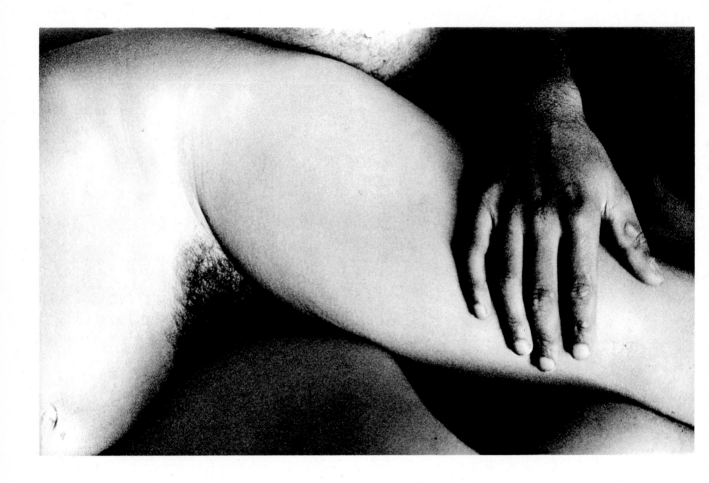

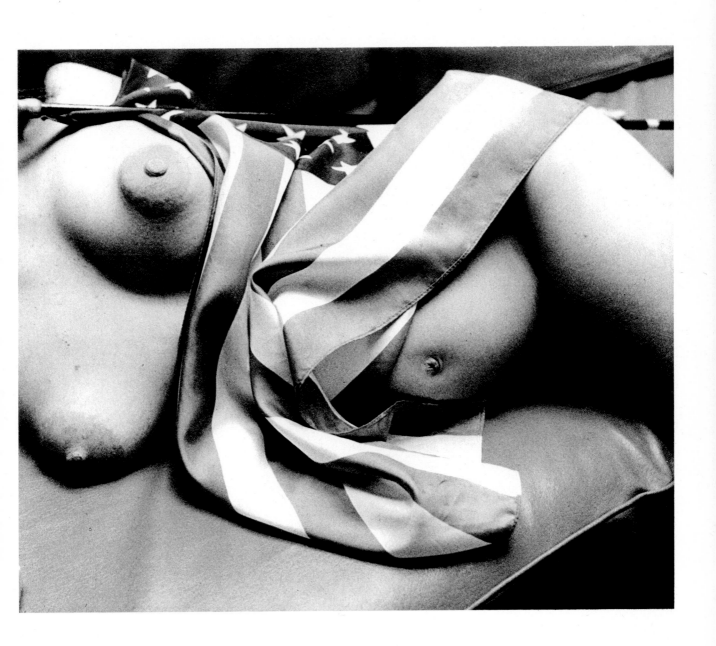

Mike Walker

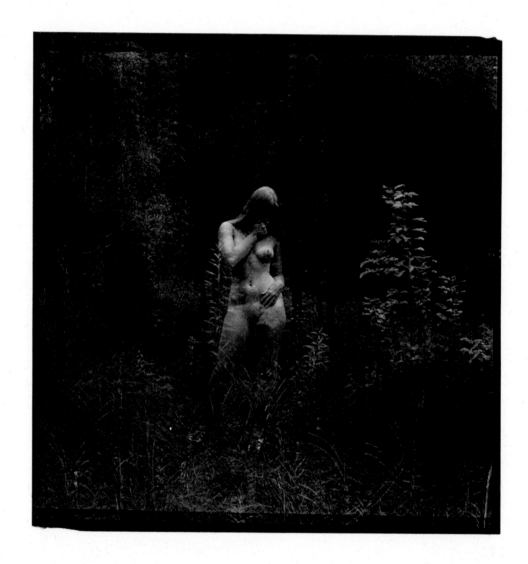

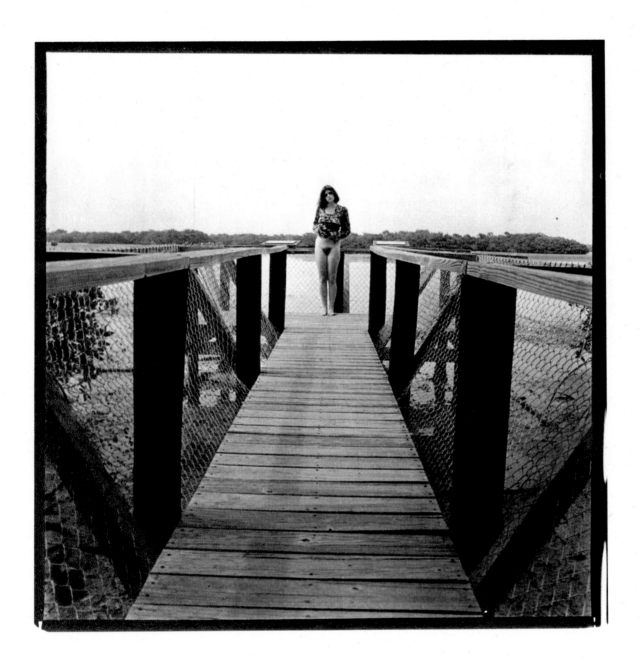

Mike Walker

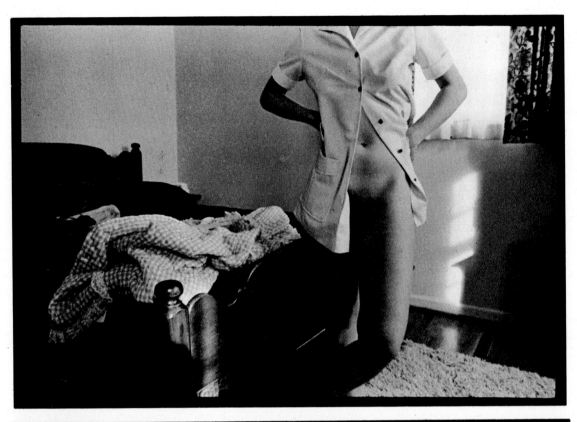

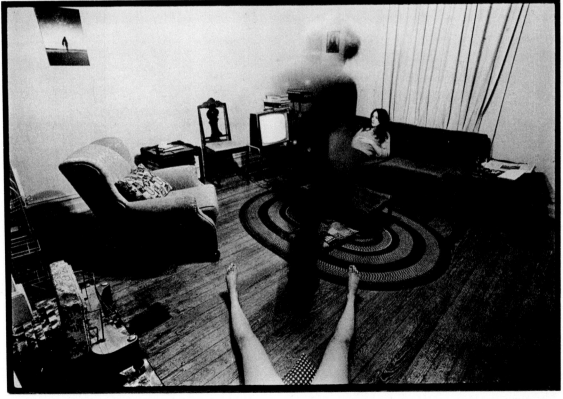

Walter Baron

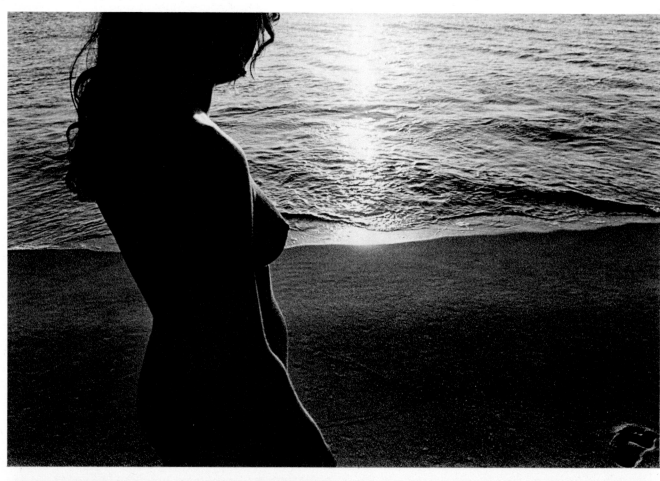

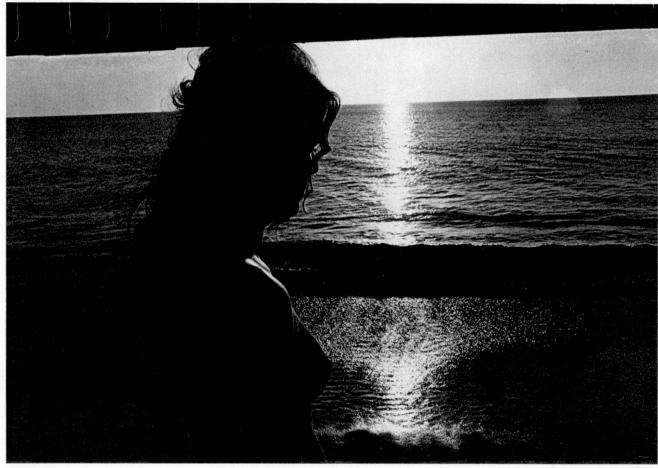

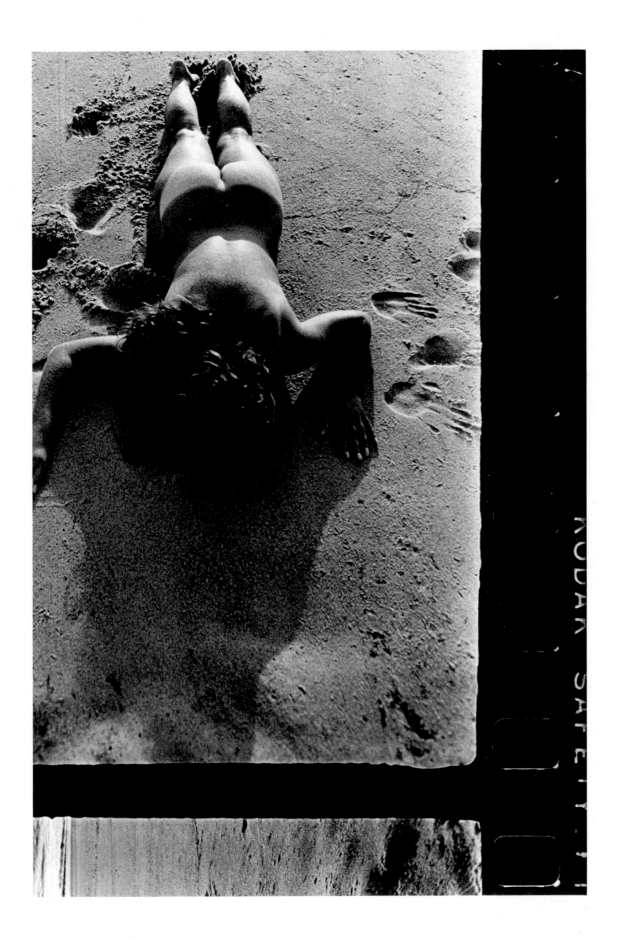

Peter Kovach

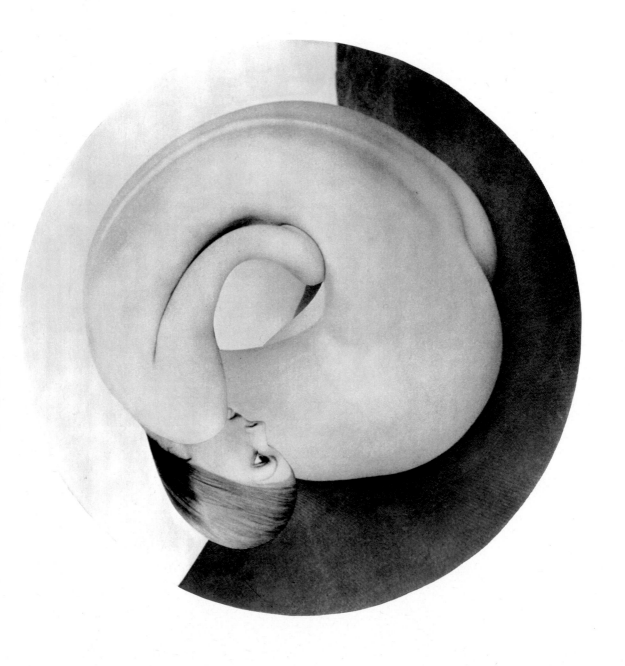

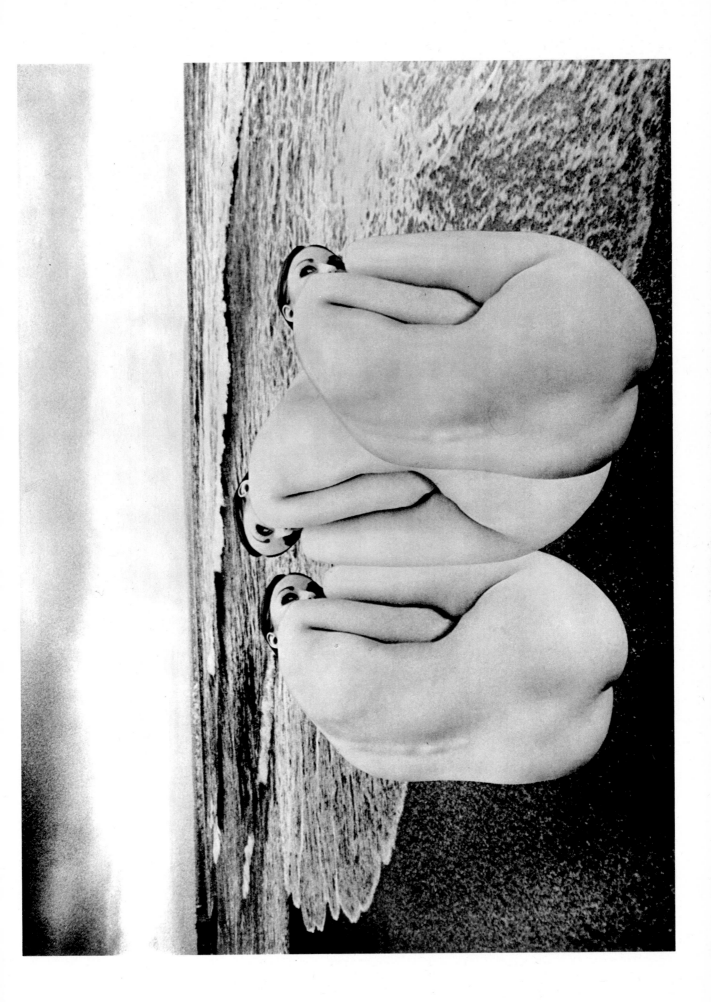

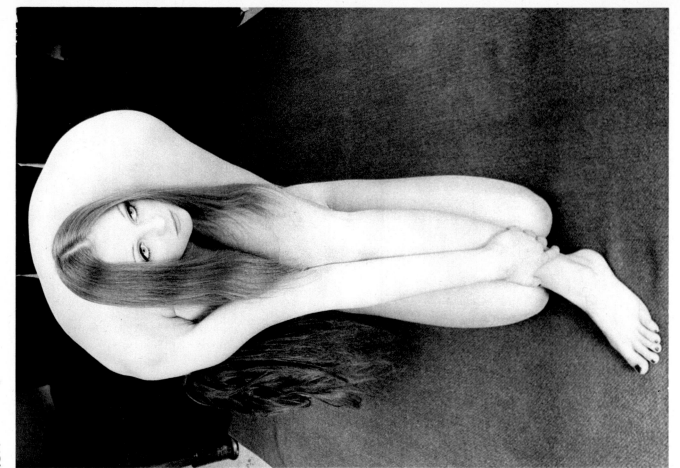

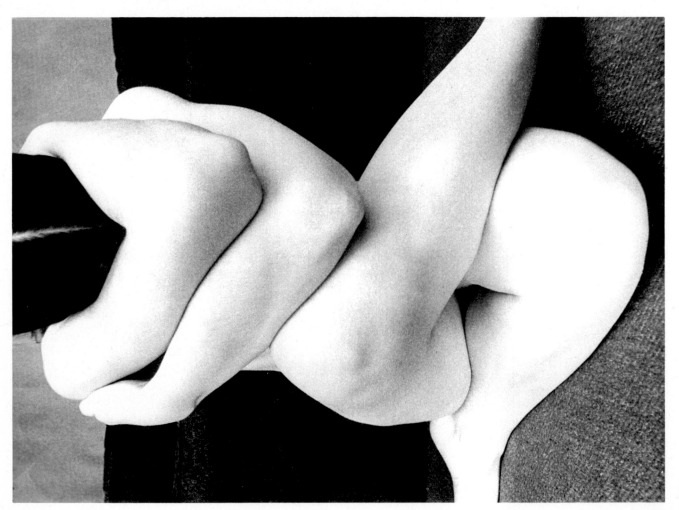

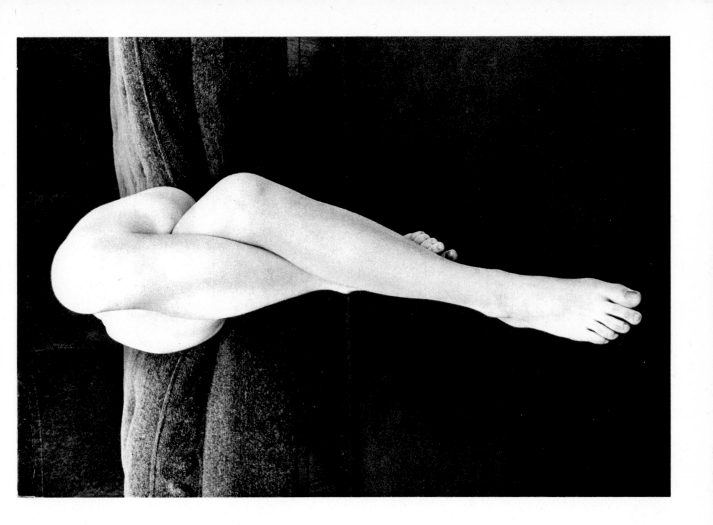

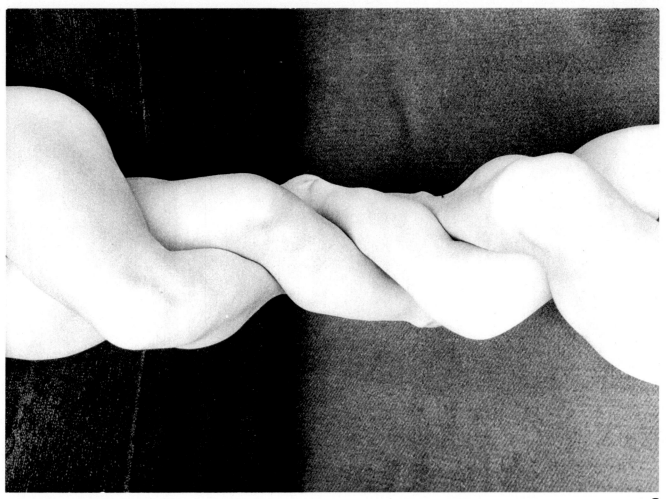

Claudine Laabs

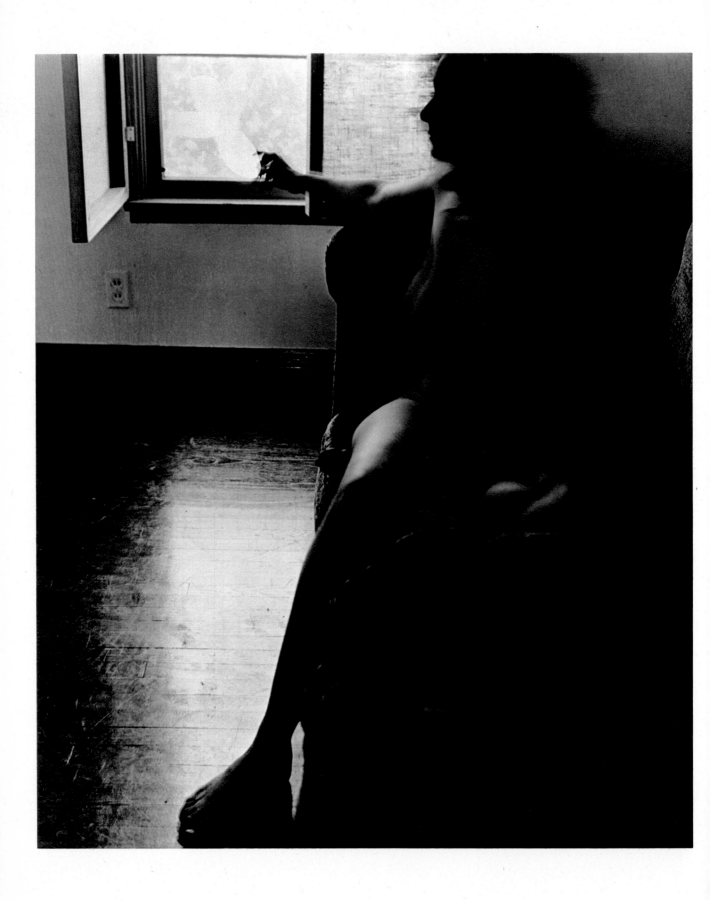

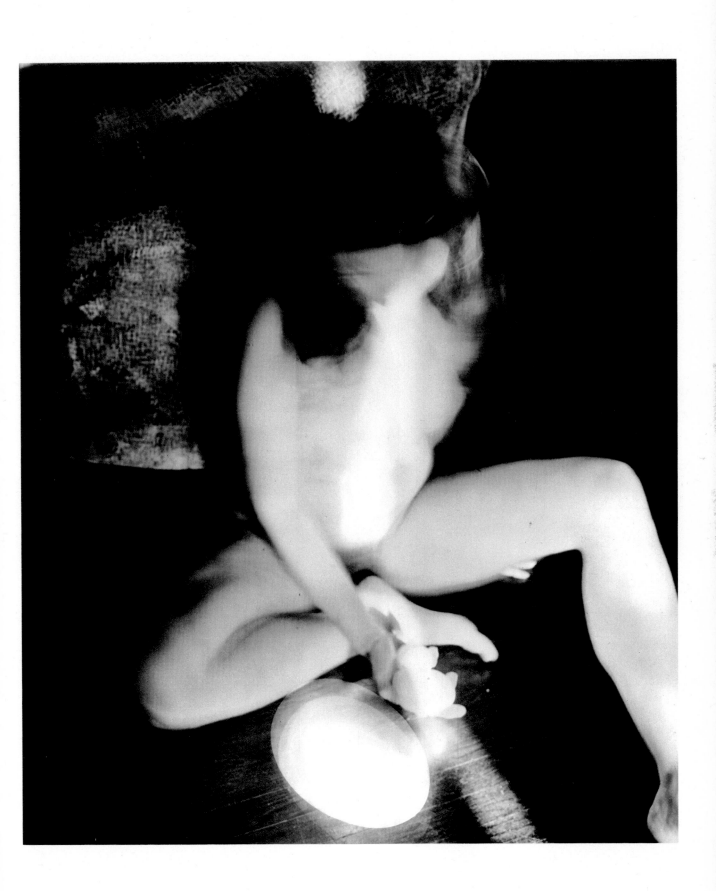

Claudine Laabs

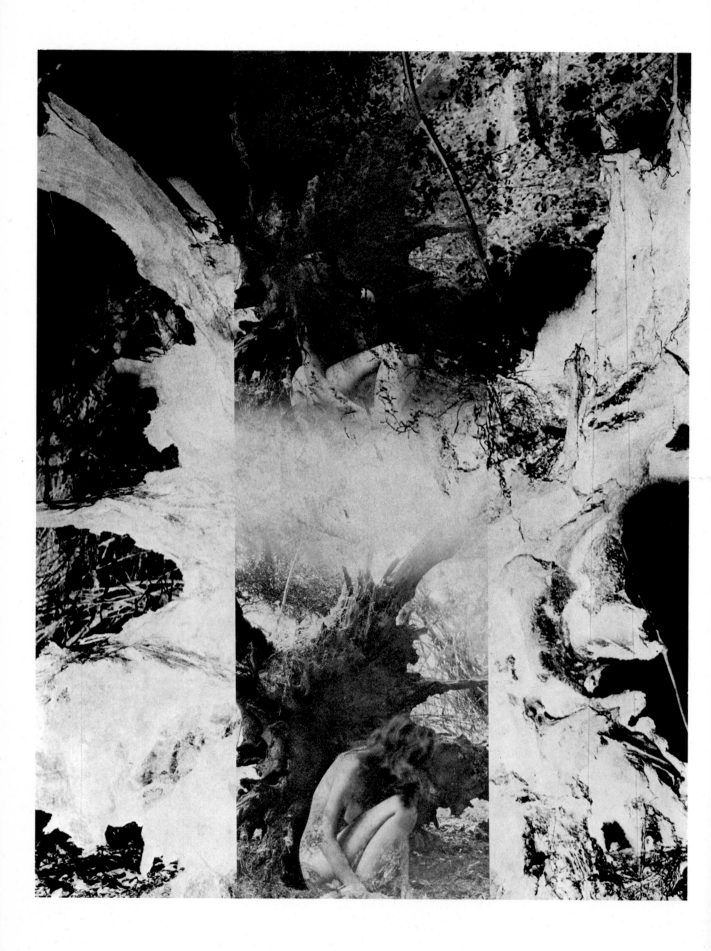

EUGENE ATGET

1857 ~ 1927

It is an interesting thought that we shall never really know if Atget saw himself as an artist. Maybe there lies the symbol of the very nature of photography. Offering his little pictures to the passers-by on the Parisian boulevards, Atget would comment: 'They are mere documents, I have thousands of them.' But if today you question Lee Friedlander —a typical representative of the American *avant-garde*—on his background he replies very simply with one word: Atget.

We know very little of Atget's life—what we know of him has been passed down verbally—and only recently the patient research of Jean Leroy has brought some new light to his somewhat ordinary existence. Atget's photographic career started late in life. Born on February 12th, 1857, in Libourne near Bordeaux, the son of a cart maker, he lost his parents at an early age and was brought up by his uncle, a station master. He became a seaman and travelled for a while on the American routes, then he decided on a career as an actor. He joined the Conservatoire in 1879 and left in 1881, but only to join a poor company that toured in the provinces and the Parisian suburbs.

This is when he met his wife and lifelong companion who bore with him the hard life of a touring actor. Not a very attractive man physically, Atget had to stick to second rate roles. In 1899 he gave up acting to dedicate his time to painting. We know that he enjoyed painting trees and landscapes—usually very well observed. In fact the few works which have survived lead us to believe that his pictorial research was very close to that of the most advanced painters of his period. In their company he learned that they often made reference to photographs. To survive Atget became a photographer. Was this his downfall and an admission of defeat or the call of deeper vocation ? These two possibilities might not be as conflicting as they seem at first glance.

He decided to specialise in views of Paris and scenes of everyday life in the city, its people, old shops, small crafts. Victorian Sardou, the playwright, would inform him of buildings threatened with demolition of which a record should be kept. Up at dawn to avoid any heavy traffic, Atget, with slightly stooping figure, clad in his long-worn-out coat, carrying his enormous apparatus weighing well over 40 pounds, would walk the streets of Paris seeking out his images.

His clients were the amateur collectors of old Parisian curios, the craftsmen, the shopkeepers of whom he made portraits, and also the artist community who acknowledged his talent and bought pictures as reference studies.

The National Archives bought documents from him and the Prints and Drawings Department at the Bibliothèque Nationale purchased albums which he built around specific themes: Parisian interiors, horsedrawn carriages, old signs etc. Nevertheless fame never came.

At the outbreak of the First World War in 1914, Atget lost many of his outlets and began to use his time in filing his negatives—about 10,000 of them. When peace returned, the artists from Montparnasse showed him the same keen sympathy as those from Montmartre had in the past. Dunoyer de Segonzac, Vlaminck, Utrillo, Braque, Kisling, Foujita, Marcel Duchamp, Picasso, Man Ray, Dignimont—who commissioned a series on prostitutes—all held him in high esteem.

In 1926, the *Review la Revolution Surrealiste* published four photographs by Atget but it was too late to introduce his talent to the contemporary art world. Very affected by the death of his wife the previous year, Eugene Atget died on August 4th 1927.

Some time before his death, Berenice Abbott, the American photographer, visiting Man Ray's studio had noticed several works by Atget. Recognising their power she set about saving all the negatives left, later taking them back with her when she returned to the States. There they have been since, in the collection of the Museum of Modern Art in New York.

We shall never know if Atget was ever aware of his own genius. Humble, taciturn, shy, he had however, very strong ideals for which he fought with great passion. From his neighbours we learn that heated discussions could often be overheard coming from his apartment. It could have been his lack of money which led him to maintain his elementary and old fashioned technique but, equally, it could well have been a recognition of the strength that lies in simplicity. He would use a vast 18 cm x 24 cm camera with bellows, a rectilinear lens which did not quite cover the plate and left dark corners on the prints, while his negatives were contact printed on citrate paper exposed by his window to sunlight. The resulting pictures in brownish-red tones were

clear and detailed, very far removed from the soft-focus images so fashionable at the time.

'Documents for Artists' proclaimed the sign Atget had put up on the door of his studio at No. 17bis rue Campagne Premiere in Montparnasse. This humble signpost says more than the words suggest. The genius of Atget lies in his having allowed photography to express itself in that most natural language which is its own: the documentary. These old houses, these street pedlars, these shop fronts, these signs, are there displayed for everybody: they are without artifice, simple and genuine. The secret of their poetry lies in the equilibrium between lines and planes so subtle it defies any analysis. It also lies in the light of an early Parisian morning. Such a discreet gentle poetry that one often thinks that this innocence was only an aspect of naivety.

But Berenice Abbott has shown that Atget's work indicated the presupposition of an amazing succession of voluntary decisions and a definite control which enabled these subjects to speak for themselves. Also a few stunning nudes, a few studies of roots and tormented trees of the quality of a Weston, are there to prove that their author was perfectly capable of a deep interest in forms for themselves. Equally, a few amazing reflections in shop windows are enough to show an acute awareness of the magic of light that goes beyond any simple document or record. Atget also knew that the harmony of the luminous caresses on an old wall or the window of a shop are enough to evoke the poetry of dying things: that is, of everything.

In the early days of photography, Talbot, Bayard, D. O. Hill, faced with very basic questions, often found their answers in amazing images. Towards the end of the last century, so satisfied with its own decadence, photography was looking for its rapport with the first revolutionary convulsions of modern art, impressionism and neo-impressionism, and in the process made itself subordinate. Atget disregarded these theories, or at least pretended to do so.

Alien to the rantings of his pictorialist contemporaries and also to the new-found magic of instant photography, Atget's pictures are almost timeless, ignored at the time by Demachy, later praised by Weston.

Atget's images radiate the intense and silent poetry of objects and beings that human vision could not soil either through desire, distortion, or misinterpretation. Images without artifice, almost pre-art and for this reason art themselves. In the light of early Parisian mornings, so transparent, so light, the 'bonhomme' Atget slowly proceeds with his huge black box. He is so humble, so patient that humble objects and humble beings let themselves be discovered as if no one was there to really look at them. Everyone has, once in their life, felt, at the corner of a lonely street, or in a wood, by the purest light and the harmony of juxtaposition, this incredible feeling of self-discovery. As if by some kind of undeserved and mysterious favour, one can face a spectacle of prime innocence, a fugitive vision of a lost paradise.

Here lies the genius of Atget, and it is the very genius of photography; to transform into a permanent image, offered to all, a moment which without this image, would have remained the ephemeral secret of one individual. Atget knew that we are never too humble to face the mystery of reality and this humility is at the very source of creation. Photography is too often put in the same category as the other visual arts. Let us ask ourselves if it is not at its very centre and root. A centre and root so deep that to see what is and to create what is not are inextricably linked.

A great artist is one who brings a new vision to his art. Cezanne used to say 'I want to paint the virginity of the world', Eugene Atget, the purest and most humble of all photographers, could have claimed the same.

Jean-Claude Lemagny,
Cabinet des Estampes,
Bibliothèque Nationale,
Paris

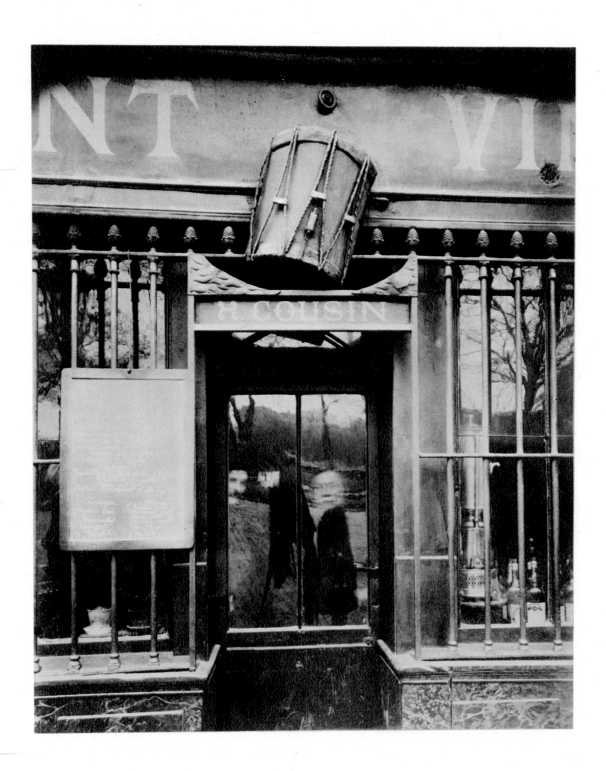

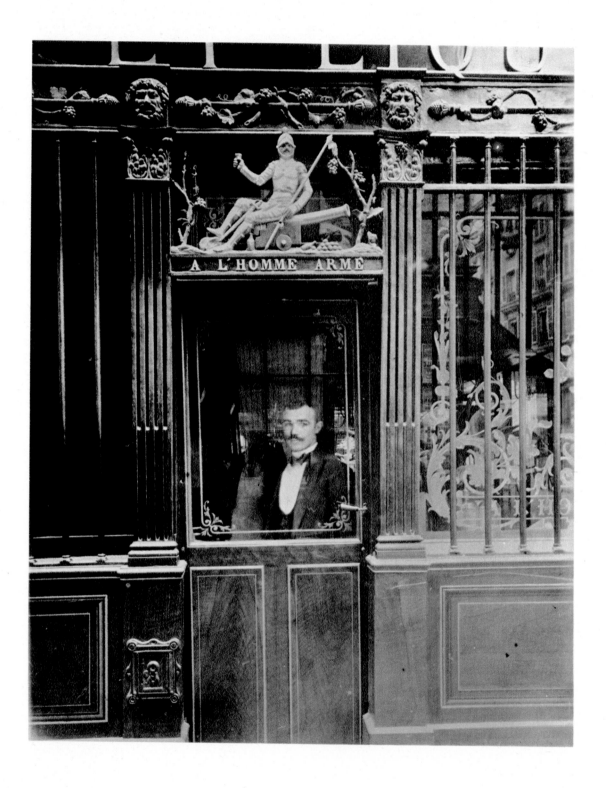

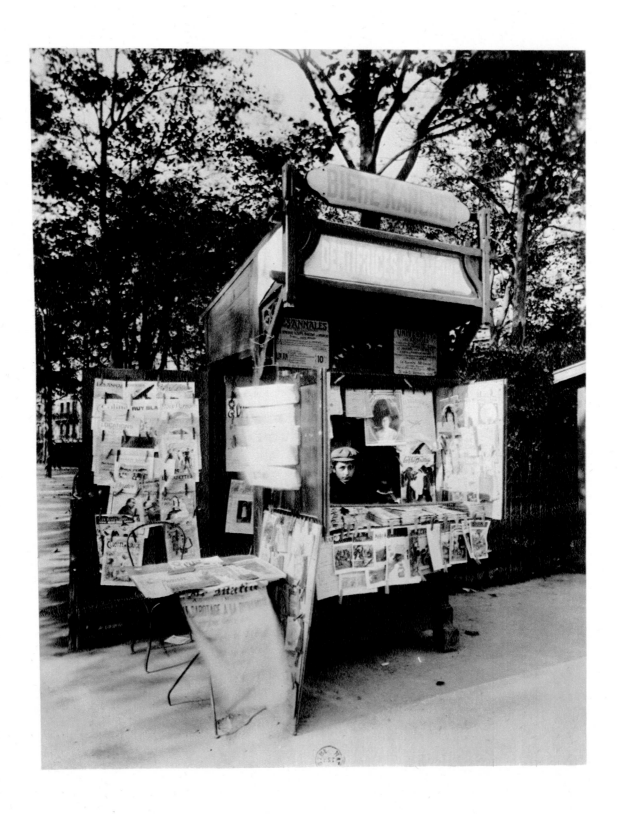

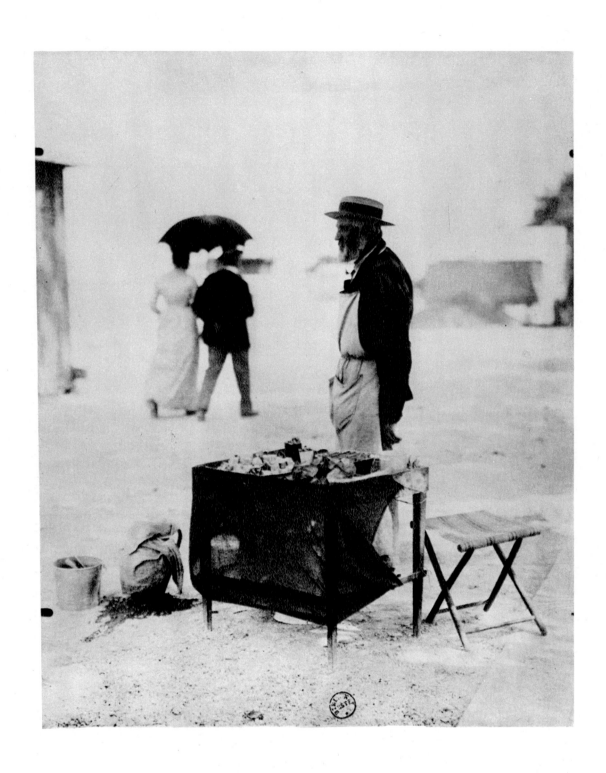

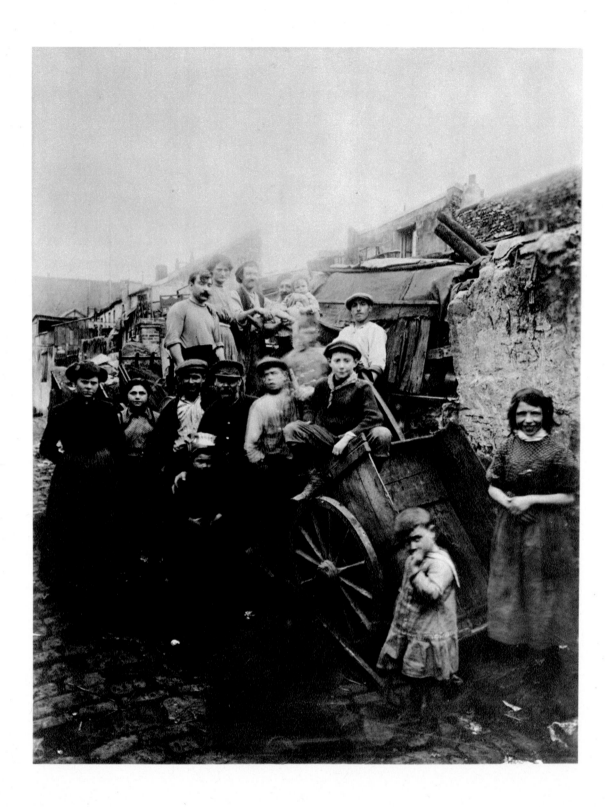

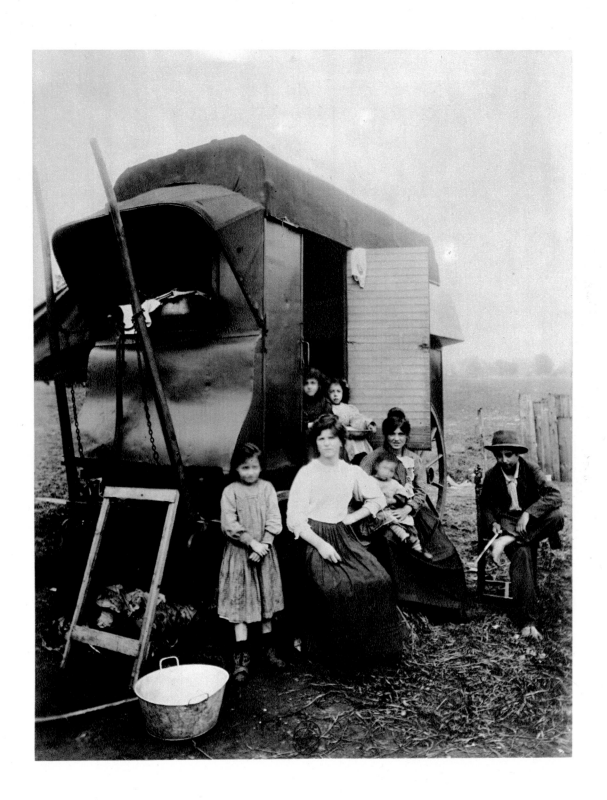

211

Processing for Posterity

In recent years there has been considerable interest in archival processing and in making sure that prints purchased by museums or private collectors will have a maximum life. Bob Arnold has examined and summarised the literature and has quoted (with permission) methods that will provide minimum standards. At the end of this article will be found a list of sources referred to which contains further and often more detailed descriptions of techniques. Although this section will not be repeated regularly we hope to update it in future years.

Part I Introduction
Extracted from the Time-Life book 'Caring for Photographs'

How long does a photograph last ? Some of the first ever made have held up perfectly, their images as durable as if they had been carved in stone. Yet other photographs not nearly so old have faded to a brownish yellow, their scenes lost perhaps forever. The crucial difference between the long lasting photograph and the faded one is the care that went into its processing. The photographer who wants to ensure extended life for his pictures should do his own processing to be certain it is handled correctly. And for those photographs he wants to endure indefinitely, he should use the special techniques that are known as archival processing and are described on the following pages. If he takes these recommended steps, he can expect his photographs to last longer than he will.

For black and white pictures, archival processing is not radically different from the customary method of developing, fixing and washing. It is basically an extension of the ordinary procedures, involving a few extra steps, some additional expense and careful attention to the fine details of the work. Its principal aim is the total removal of chemicals that, although essential to the picture making operation, can ruin the image if allowed to remain in a finished negative or print.

Among the potentially harmful substances that archival processing seeks to remove are the very ones that create the normal black and white image: salts of silver, such as silver bromide or silver chloride. During development those grains of silver salts that have been exposed to light are reduced to black metallic silver, which forms the image; but unexposed grains are not reduced and remain in the form of a silver compound. If this is not removed, it will darken when struck by light and blot out the image. The chemical used to remove these unexposed grains is fixer, or hypo, which converts them into soluble compounds that can be washed away. The fixer, however, must also be removed. It contains sulphur and, if allowed to remain in a picture, it will tarnish the metallic silver of the image just as sulphur in the air tarnishes a silver fork. Also, fixer can become attached to silver salts to form complex compounds that are themselves insoluble and cannot be easily removed. When these silver fixer complexes decompose they produce a brown-yellow sulphide compound that may discolour the entire picture. Archival processing includes procedures that eliminate

the last traces of these residual chemicals—unreduced silver salts, fixer and silver fixer compounds. Washing alone, for example, cannot make a print entirely free of fixer; even after 20 hours in running water a slight but potentially harmful amount of fixer would remain and such prolonged washing would itself endanger the print by weakening the paper fibres. Once the picture is clear of residual chemicals, the final step in the archival procedure is to protect the image with a special treatment using a gold or selenium compound. Either of them unites with the silver in the image to act as a shield against damage from external contaminants, such as the sulphur that is part of the pollution in the air.

Archival processing calls for special care in several respects. Meticulous cleanliness is essential to the success of archival processing. Sloppiness defeats the technique's purposes by introducing materials that can cause image deterioration. Any chemicals left to linger in trays or bottles may contaminate the solutions next used in them. Similarly, chemical residues in sponges or blotters could be passed on to the picture.

The processes also depend heavily on careful preparation of the several working solutions. The formulas must be followed exactly (although they may be reduced proportionately to make small batches). While excess quantities of most solutions can be stored (in amber bottles to prevent light-caused deterioration) it is wise to discard any leftovers and make up fresh batches each time. That way there is no risk of employing chemicals that have spoiled or have been exhausted through use.

To eliminate completely the chance of contamination clean the darkroom frequently paying particular attention to any equipment which comes in contact with the solution tanks, tray, tongs, clips, etc., all of which tend to accumulate deposits which can cause solution contamination. (Ostroff.)

Part II Special Treatment for Negatives

The steps that ensure long life to negatives begin after the film is developed in the ordinary way. It is fixing, washing and later treatments that determine how permanent the image will be.

In fixing negatives, extra protection is gained by using two separate baths in order to make certain that fresh solution reaches every part of the emulsion. Either of the two standard types of fixer, ammonium thiosulphate ('rapid' fixer) or sodium thiosulphate, may be used, provided the temperature of the solution does not exceed 24°C (75°F). After a normal stop bath has been used and poured from the tank, add the first fixer bath and agitate for half the recommended time; then discard the solution. Next fill the tank with the second fixing bath and agitate again for half the recommended time. The exact fixing times *must* be observed. If the film is underfixed, silver halides will linger in the negative. If it is overfixed, insoluble silver-fixer compounds may form.

Once fixing is finished, the fixer and its by-products must be totally removed from the film. Empty the tank and fill with rinse water. Agitate the reels of film several times by lifting them up and down by the central rod, discard the rinse water and fill the tank with a standard hypo-clearing agent. Agitate the film in this solution for 3 minutes.

Kodak Hypo Clearing Agent (KHCA) is a mixture of inorganic salts. It is not the same as Hypo Eliminator. KHCA was evolved from research during World War II when it was discovered that sea water hastens removal of hypo from photographs. Following treatment in hypo, rinse prints for 1 minute in water, and then immerse in KHCA for 2 minutes. The last traces of hypo are then chemically destroyed by immersing them for 6 minutes in hypo eliminator. See formulae etc. in appendix (Ostroff.)

Only after rising and clearing is the film ready for washing, preferably in an archival washer, a device designed to provide great water exchange and circulation without excessive turbulence. If the developing tank is to be used as a washer, insert the connecting hose deep into the tank to make sure that the water circulates completely. To make sure such a setup provides sufficient water flow, test it by placing several drops of ordinary food colouring inside the tank. The flow should clear the water of all

231

the dye in 5 minutes or less. Wash for 10 minutes, and for optimum results keep the water temperature between 20°C and 24°C (68°F and 75°F).

After the washing, a simple test for residual hypo in the film should be made. One such test is made by using Kodak Formula HT-2. To use the hypo test solution, first cut off a strip from the wet film's clear margin and blot the water remaining on the surface. Using a dropper, place one drop of test solution on the clear area and allow to remain for 2 minutes. Blot off the excess and compare the stain that appears with one on a Kodak Hypo Estimator Sheet, which may be purchased at many camera stores. The stain on the test area should be appreciably lighter than the lightest stain on the estimator sheet. In fact, the test area should show very little stain at all. If the test stain is too dark, continue the washing for a while and test again.

Once washing is completed, that is, after all traces of fixer have been eliminated, the silver image can be protected against chemical attack by treating it with a gold solution. The solution used for negatives is the same as the one employed for prints. For treating film, fill the developing tank with the gold solution and agitate the film in it for 10 minutes. Then rinse and wash for 20 minutes. This process will give film an impervious surface without altering image tones. The final steps in processing film for durability are those that will guarantee even, safe drying. Fill the developing tank with any standard photographic non-ionic wetting agent that has been diluted in distilled water (not tap water), and agitate the film in it for a minute. The agent decreases the surface tension of water, allowing it to flow off the film evenly without collecting drops or leaving streaks; sponging to remove droplets should not be necessary. Now hang the film on clips to dry at room temperature; do not use heat, which may cause film to become brittle.

Part III Toning

Prints, like negatives, gain durability from additional stages taken after normal development however with a print there is not only the question of density and durability which is all that is required of a negative but the additional and most important aspect of visual quality. The toning processes used to obtain protection can also be used to achieve a variety of visual effects but the processes detailed provide protection with virtually no alteration in visual quality. Gold toning is generally held to be more protective than Selenium but no comparative data is available for the degree of protection afforded. Either may be preferred for its ultimate appearance. Prints should be given normal full development in fresh developer, rinsed in an acetic acid stop bath for 20–30 secs., drained and transferred to a Sodium Thiosulphate fixing bath. The use of rapid fixers is not recommended due to the difficulty of accurate control.

Agitate constantly for 2 minutes at which time it is safe to turn the white room lights on. Agitate for another 2 minutes (which makes a total of 4 minutes in the first bath), remove the print and place it in a tray of running water. If you don't have running water in your darkroom, change the water in the tray every time you add 3 or 4 prints. If you do a great deal of printing it might be advisable to have a print washer next to the first fixer tray to 'store' prints between fixing baths. It is important not to add prints to a tray of stagnant water, as the concentration of fixer will rapidly increase and the fixing action will continue.

When eight or ten prints have accumulated in the wash, take all of them out and rotate them through the second, *fresh* fixing bath for 4 minutes. 'Rotating' the prints means *constantly* lifting the print off the bottom of the pile in the tray and placing it on top of the rest of the prints. Do this operation with your hands as attempting to rotate the prints with print tongs will probably result in damage to the prints. This process will give all the prints more or less even contact with the processing solution. At the end of the 4 minute period, take the prints out of the fixer, one by one, and place them in a rinse tray of running water or in a print washer. If a tray is used, rotate the prints through this rinse 4 times, changing the water in the tray each time. The prints can then be 'stored' in a tray of clean water until ready for the toning process. (East St Gallery.)

Selenium Toning
Carried out immediately after fixing. To a gallon of Hypo Clearing Agent working solution add 1½ oz. of Toner concentrate. Immerse the print in this solution with constant agitation for 3 to 5 mins. Remove, rinse in running water and wash until the hypo test solution produces a barely visible stain. The residual hypo which it is impossible to remove completely by washing can be eliminated by the use of Kodak Hypo Eliminator.

Gold Toning
After fixing and rinsing the print should be immersed in a Hypo Clearing Agent for 3–5 minutes with constant agitation then rinsed, washed, and treated with hypo Eliminator as for the selenium toned print.

Place the washed print while still wet in the gold solution and agitate for 10 minutes or more until a just perceptible change of image colour occurs. This change will be towards a bluish-black. Rinse and wash for 20 mins.

Part IV Drying Archival Prints
Extracted from 'East Street Gallery Procedures'

Print drying is a crucial but usually neglected operation. If you go through all the steps previously described to produce an archival print and then put the print between some old blotters or on your old certain-to-be-contaminated dryer sitting in your darkroom you will have undone all your previous efforts.

We strongly believe that fibre-glass drying screens are the *only* satisfactory method of drying archival prints. Fibre-glass screening, which can be easily obtained at most timber yards and some hardware stores, is cheap, does not absorb moisture or retain chemicals, and can be easily washed from time to time to make certain it is clean. This material was designed to be used in window screens in place of the usual wire screens.

One can easily make wood frames (using pine 1 ″ x 2 ″) to stretch the fibre-glass tight and then suspend the frames from the ceiling with wire or string. If space is at a premium you can fasten a piece of wood to each end of a long length (say, 10 feet) of fibre-glass screen and roll the assemblage up when you are not using it. This arrangement resembles a hammock when in use. Fibre-glass screening material is made in several widths, the widest easily obtainable being 48 ″ wide. This is the most satisfactory width for most applications as you can place two 11 ″ x 14 ″ prints end to end across it. You may also be able to find, especially in U.S.A., pre-made screens with aluminium frames—these will save you the trouble of making them.

You can suspend a number of these frames from a ceiling with about a foot of space between them, to give you a tremendous print drying capacity. Another advantage of drying prints by this method is that it requires very little labour on your part. You simply spread the prints out face down on the screens and return about eight hours later (depending on the humidity) to pick up the dry prints. You don't have to pay constant attention as is necessary with usual electric dryer.

Photo blotters are to be avoided for drying archival prints as they will absorb chemicals from any print which has not been perfectly processed and then contaminate subsequent prints which are dried between them. If you should use blotters, make very sure that they are *photographic* grade blotters. Other blotters contain sulphur compounds which will ruin your prints. Be very careful about this; many cheap blotters which claim to be safe for photographs are in fact very unsafe.

The best thing to do is to avoid blotters altogether. Heated dryers using cloth belts or print covers are to be avoided because the cloth will absorb chemicals from badly processed prints, print flattening solutions etc., and will contaminate all subsequent prints.

Prints which are to be dried on fibre-glass screens should be prepared thus:

1. Lay the print face down on a *clean* stainless steel or chrome-plated brass ferrotype plate (or heavy sheet of glass) and wipe the back with a blade type rubber squeegee. Hold a corner of the print with your fingers to keep

it from sliding. Wipe *away* from the point where you are holding the print or you may crease and ruin it. Be especially careful with single-weight papers.

2. Lift the print by a corner and hold it in the air while you wipe the plate dry with the squeegee.

3. Place the print face-up on the plate, again holding the corner with your fingers, and wipe the face with the squeegee.

4. After you squeegee the print, place it on a *clean* inert surface like a sheet of polyethylene to await drying. Don't put your prints in a photographic tray as it probably has a small residue of chemicals on its surface which will contaminate the print. This is especially true with plastic trays which *all* absorb small amounts of chemicals into the plastic. Stack additional prints *face-to-face*, this prevents lint pick-up from the back of one print to the face of another.

5. Then, place the prints *face down* on clean fibre-glass screens to dry. They will dry flattest in a humid place with minimal air circulation (basements are often very good for this).

Don't ever use a print flattening solution on prints processed for maximum permanence. Most such solutions contain hygroscopic substances (absorb moisture out of the air to swell the print emulsion) and are *very* detrimental to print permanence. The importance of avoiding these substances cannot be overemphasised.

Flattening Prints With Heat After Drying
The easiest and we think the best way to flatten prints is to press them, one at a time, in a dry-mounting press (at about 250 °F). Place the print between a couple of sheets of clean *100% rag* acid free paper while it is in the press. Leave it in the press for about 30 seconds.
You can also flatten prints by pressing a stack of them under a weight for about 24 hours.

The image thus achieved, free from 'built in' contamination and with its silver image protected by the gold coating will still depend for its long life expectancy on the care with which it is stored. The emulsion is particularly sensitive to the gases given off by low grade paper products such as the boxes and envelopes usually employed for storage. Polyester, Polyethylene or Acetate (not Glassine) sleeves which can be kept in binders are the best solution to date. Storage should be in stove enamelled steel cabinets.

Formulae etc.

1. Kodak Hypo Clearing Agent (KHCA)
Available from Eastman Kodak, U.S.A. and Kodak Limited, England.

Other commonly used washing-aids may be substituted for Kodak Hypo Clearing Agent. These include HEICO Perma-Wash and GAF Quix. Though we have not tested them, we assume that other washing-aids would be satisfactory for this application. These include among others: Edwal Hypo Eliminator, TKO Orbit Bath, Hustler Rapid Bath, BPI Hypo Neutralizer No. 30. Mix as directed for a working solution of washing-aid.

2. Hypo Eliminator
Water	500 ml
Hydrogen peroxide	125·0 ml
Ammonia solution	100·0 ml
(1 part 28% ammonia to 9 parts water) to make	1·0 litre

Prepare immediately before use; do not store in sealed bottle.
After treating prints in KHCA immerse them in hypo eliminator for 6 minutes at 20 °C (68 °F); follow with a 10 minute wash.

3. Residual Hypo Test Solution
(Kodak formula HT 2)

	Avoirdupois	Metric
Water	24 oz	750 cc
28% acetic acid	4 oz	125 cc
Silver nitrate	¼ oz	7·5 gm
Water to make	32 oz	1·0 litre

Since only a drop or so is used at a time this solution lasts a long time. Both compounds are available from most chemical supply houses but acetic acid is generally sold in special concentrated 'glacial' form and must be diluted, three parts to eight parts distilled water, to get the 28% strength needed.
(Solution should be stored in a sealed brown bottle away from strong light. Avoid contact with skin and clothing, otherwise stains will result.)
Place one drop on edge of clear margin area. Let stand for 2 minutes, blot excess. Anything more than a very light stain indicates eventual discoloration.

4. Kodak Hypo Estimator Sheet
Available from Eastman Kodak, U.S.A., not available in England.

5. Gold Toner, Protective Strength
Water	750 ml
Gold chloride (1% stock solution 1 gram: 100 ml water)	10·0 ml
Kodak sodium thiocyanate (liquid)	15·2 ml
Water to make	1·0 litre

The gold chloride stock solution is added to the volume of water specified. The sodium thiocyanate is mixed separately in 125 ml water and then added slowly to the gold chloride, while stirring rapidly.

6. Selenium Toner
	Avoirdupois	Metric
Kodak Hypo Clearing Agent* working solution	1 gal	4·0 litres
Kodak Rapid Selenium Toner concentrate	7 oz	200·0 cc
Kodak Balanced Alkali	2½ oz	75·0 grams

Kodak Rapid Selenium Toner concentrate is not available in the U.K. A Selenium Toner formula appears in old B. J. almanacs but we have *not* tested this formula to see if it is suitable.

7. B. J. Selenium Toner Formula
Selenium powder	3·4 gm.
Sodium sulphite	52 gm.
Water	500 cc.

Warm the solution to make sure the selenium is dissolved, then dilute well with water for use according to tone desired. A suggested dilution for colour toning is one part stock solution to 10 parts water. The working solution should be discarded after use. (N.B. Not tested for protective use.)

8. Selenium Toner, Protective Strength
Note: The formula 6 will give a visually perceptible toning effect along with a noticeable intensification of the blacks with papers such as Agfa Brovira and Kodabromide. To make a combination solution for protective effect *only*, reduce the amount of selenium toner to 1½ oz. per gallon of washing aid working solution and omit the alkali.

Sources:
Time-Life Books: Life Library of Photography, *Caring for Photographs,* available from bookshops or by mail from Mansfield Books International, 19 Doughty Street, London WC1N 2PT. (Price £5·10)

Ostroff, Eugene: Paper delivered at RPS Historical Group Symposium 16 March 1974. The papers can be obtained from the RPS Secretary, 14 South Audley Street, London W1.

East Street Gallery: Procedures for Processing and Storing Black and White Photographs for maximum possible permanence (1970), copies of this 48 page booklet are obtainable from the East Street Gallery, or from Mansfield Books International, 19 Doughty Street, London WC1N 2PT. (Price 50p)

Eastman Kodak (Rochester): B/W Processing for Permanence Pamphlet T-19. Revised 1970. Not available in U.K.

This Creative Camera International Year Book is published by Coo Press Ltd., 19 Doughty Street, London WC1N 2PT, a private company independent of all large publishing houses. Coo Press Ltd. also publishes Creative Camera, a monthly magazine available on subscription in any part of the world. Our overseas agents are the same as those for this Year Book.

A separate division of Coo Press is Creative Camera Books which has a book list of approximately 100 titles covering historical, cultural and artistic aspects of photography. This list is available by post and includes those publications for which we are exclusive European agents. Also included are special offers, publishers remainders etc. which we have obtained at reduced prices and which we are able to offer at exceptionally low cost for limited periods.

Another subsidiary of Coo Press is Mansfield Books International, a mail order company that specialises in practical and technical books. Includes approximately 100 selected titles featuring the most important books in the field. Between the two lists we are able to offer the basis of any library and given title, author and publisher can obtain any photographic book currently in print.

Although the book departments are primarily mail order a limited range of titles is kept in our Book Shop Gallery for those who wish to examine books. The Gallery is a small space and is used primarily for exhibitions by young photographers and experimental work shown in connection with articles appearing in the magazine. Finally, we are British subscription agents for Aperture, and U.K. distributors of the Swiss magazine Camera and International Photo Technik, a quarterly devoted to large format photography.

For information on any of these activities, please write to the appropriate division at the address above, quoting Dept. Y.B.1.